# Photography for Kids!

Michael Ebert is a photographer and teacher of photojournalism at the university in Magdeburg, Germany. He formerly worked as a newspaper and magazine photographer. He also prepares exhibits of famous photographers' work and has written extensively about photography.

Sandra Abend studied art history with a focus on photography and wrote her dissertation about the photographs of Jeff Wall. She directs the Kinderartothek of the Wilhelm-Fabry-Museum in Hilden, Germany, and she teaches at the University of Düsseldorf in Germany. Sandra and Michael have been running photography workshops for children for a number of years.

Michael Ebert & Sandra Abend

# Photography for Kids!

## A Fun Guide to Digital Photography

**rocky**nook

Michael Ebert · Sandra Abend, mail@photomoments.de

Editor: Gerhard Rossbach
Translator: David Schlesinger
Copyeditor: Jeanne Hansen
Layout: Lilia Bauer
Typesetting: Petra Strauch
Cover design: Helmut Kraus, www.exclam.de
Printed in China

ISBN 978-1-933952-76-5

1st Edition
© 2011 by Michael Ebert and Sandra Abend
Rocky Nook Inc.
26 West Mission Street, Ste 3
Santa Barbara, CA 93101
www.rockynook.com

Library of Congress Cataloging-in-Publication Data

Ebert, Michael (Michael Roland), 1959-
 [Foto-Workshop für Kinder. English]
 Photography for kids! : a fun guide to digital photography / Michael Ebert, Sandra Abend. -- 1st ed.
     p. cm.
 ISBN 978-1-933952-76-5 (hardbound : alk. paper)
 1. Photography--Digital techniques--Juvenile literature.  I. Abend, Sandra. II. Title.
 TR267.E2413 2011
 775--dc22
                          2010052896

Distributed by O'Reilly Media
1005 Gravenstein Highway North
Sebastopol, CA 95472

## Acknowledgments

Thanks to Anja, Anna, Antonia, Charlotte, Felix, Javed, Kasandra, Lea, Melina, Neele, Nele, Phillipp, Pia, Selin, Talia, Tamar, Vicky, and the many other children who helped us with this book. Thanks also to Canon for technical support.

# Table of Contents

# Foreword

What is it about taking pictures that interests us so much? There are many reasons people like photography. For starters, it's fun! It's exciting to capture snapshots of fascinating moments, people, animals, places, and things. When we grow older, we can look back at our pictures to remember a great vacation or a special first day of school. In some ways, photographs become our memories; they can bring the past back to life. Ask your parents if they have old photos of your great-grandparents from when they were children.

▶ Taking photographs was a special occasion for past generations. In the picture on the right, you can see how fascinated these children are by the camera of American photographer Frances Benjamin Johnston. She was a pioneer of photography. This picture was taken around 1900.

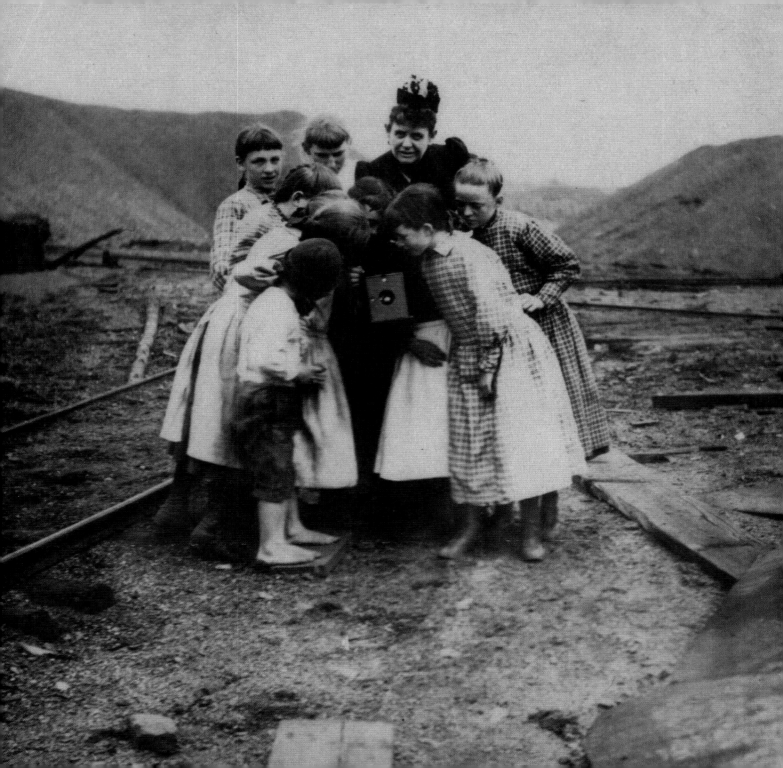

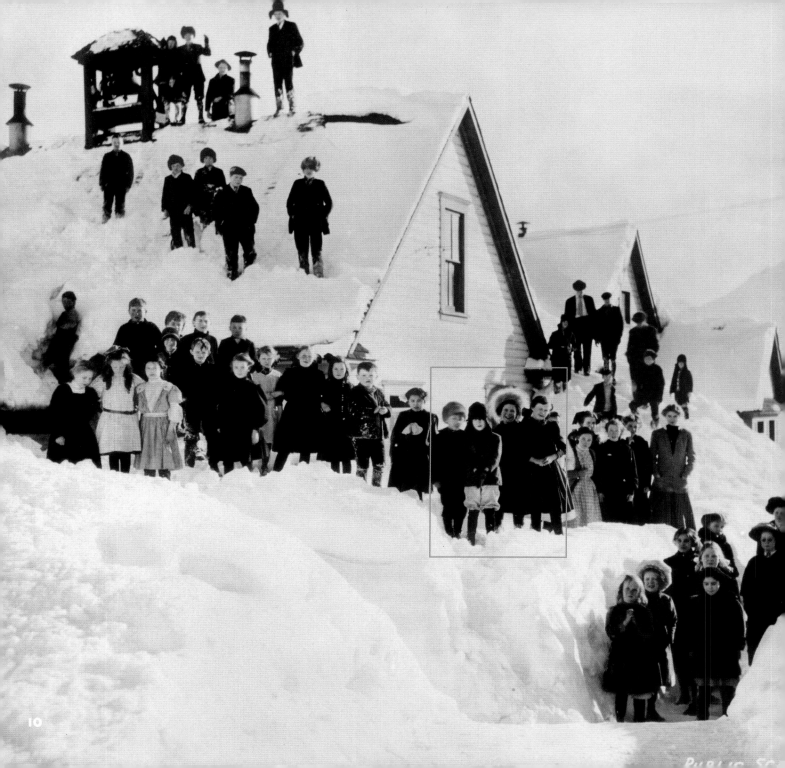

Photographs are made with a device that captures a real moment and portrays something that actually happened (unless the picture is changed afterwards on a computer). A photo shows a brief moment in life, like someone laughing, blowing out birthday candles, or scoring the winning goal in a soccer game.

Photos have lots of uses. Advertisements use pictures to show us what we can buy. Newspapers print pictures so we can see what happens in the world. Crime scenes are photographed so the police can save clues. We can even buy posters of our favorite movie stars to hang on our walls. And most Internet sites are filled with pictures.

◄▲ A century has passed since this picture of a school in Alaska was taken in 1910. Even though these people are probably no longer living, the liveliness of the children makes it seem like the photo was just taken.

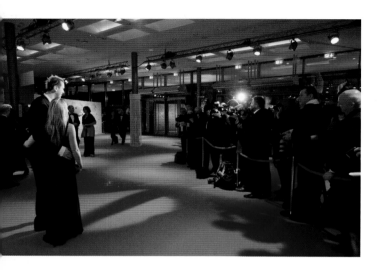

▲ What would become of stars without the photographers who follow them on the red carpet?

Taking pictures today is easier than it used to be. Modern cameras are so technically advanced that everyone can take good pictures. But we can take better pictures if we know a little about the technology of photography and the composition of a photograph. We'll explore this throughout the book, and you'll find lots of ideas for exciting and unusual pictures so you can have even more fun.

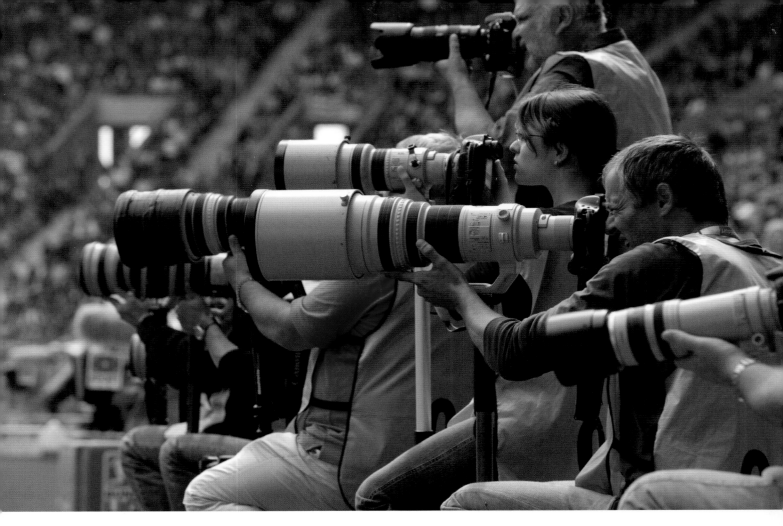

▲ Photographers today follow the action everywhere, like here at a professional soccer game.

# How it All Got Started

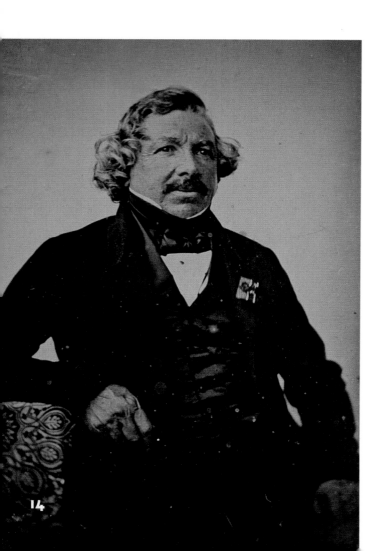

Photography hasn't always been around. It was invented in 1839 by a Frenchman named Louis Jacques Mandé Daguerre. At first the process was complicated. It took forever for a picture to be finished, and early cameras were large and very heavy. It goes without saying that there weren't any digital cameras or computers. Photographers used glass plates that had to be developed to make pictures. This meant that there weren't many photographers, and the few people who did take pictures were professionals. If you wanted a photo of yourself you had to go to a photography studio, and this was a special occasion. This is why families owned very few pictures.

◀ Louis Jacques Mandé Daguerre, the inventor of the first camera.

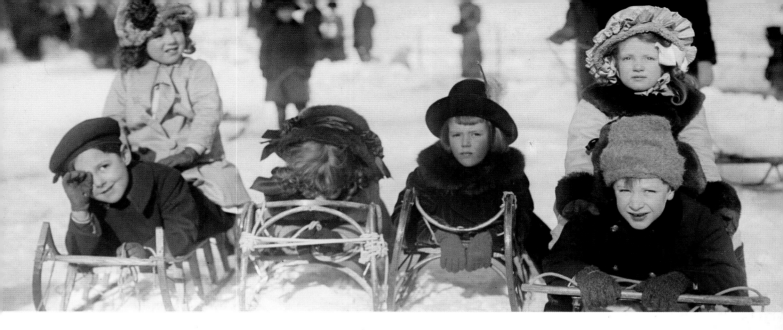

The invention of photography was a real revolution. Before photography, the only way to make pictures of the people and things around us was to paint them. After the resourceful American, George Eastman, invented film in 1889, taking photographs became easier and less expensive. Soon more and more people wanted to capture pictures of their world, and photography became popular. Around 1900, people started printing pictures in newspapers.

Film was used to take pictures until the end of the last century. Affordable digital cameras first became available around 2000. Your parents can probably remember taking their film to a store to be developed. This took a while, and sometimes you couldn't see your finished pictures for days. Today everything is faster and easier. Technology and computers allow us to avoid using film so we can see our pictures immediately. It also costs much less than before.

# Taking photographs used to be a special occasion.

# A Photo

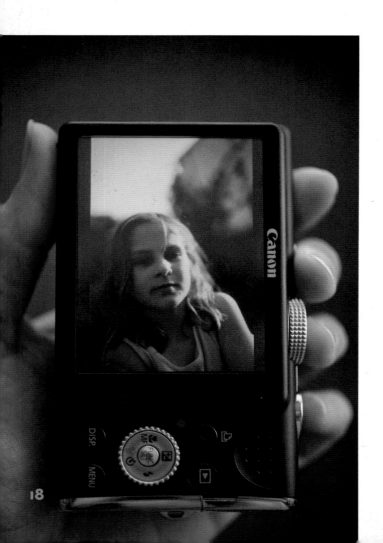

A photo is created by light—sunlight, for example, or the light of a lamp. Any object that receives light also gives off light. This is called *reflection*. Light-colored things, like a white T-shirt, reflect much more light than dark-colored things, like a pure black cat. Reflected light can be absorbed and saved. This is how we create exact copies of the people or things we photograph. Everything we capture appears as it did in the exact moment the light was absorbed and saved. The copy of the absorbed light is called the *captured image*, and the machine we use to capture the light is called a *camera*.

◀ On the back of your camera you can see the Live View screen.

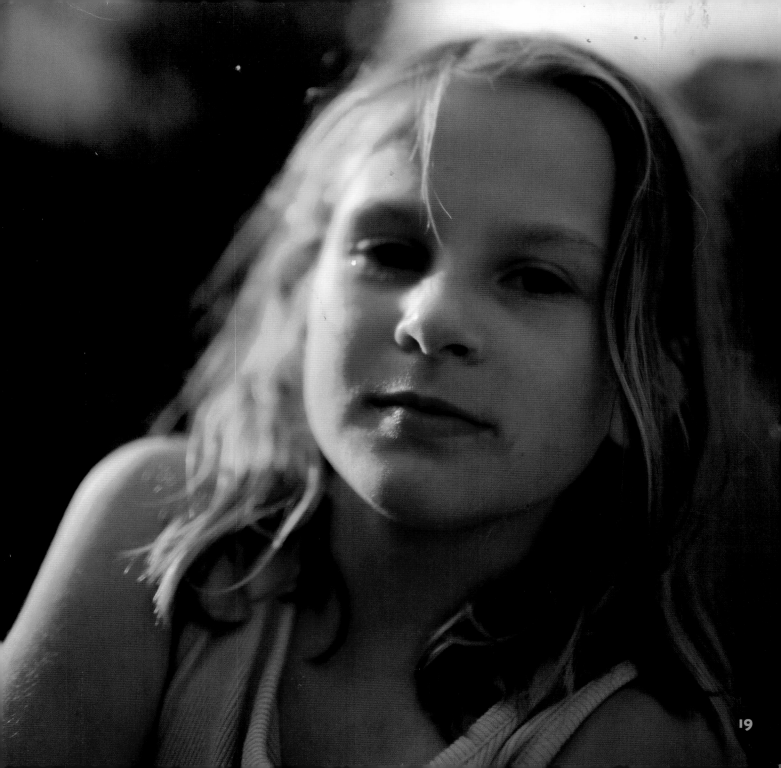

# Photos capture passing moments in life.

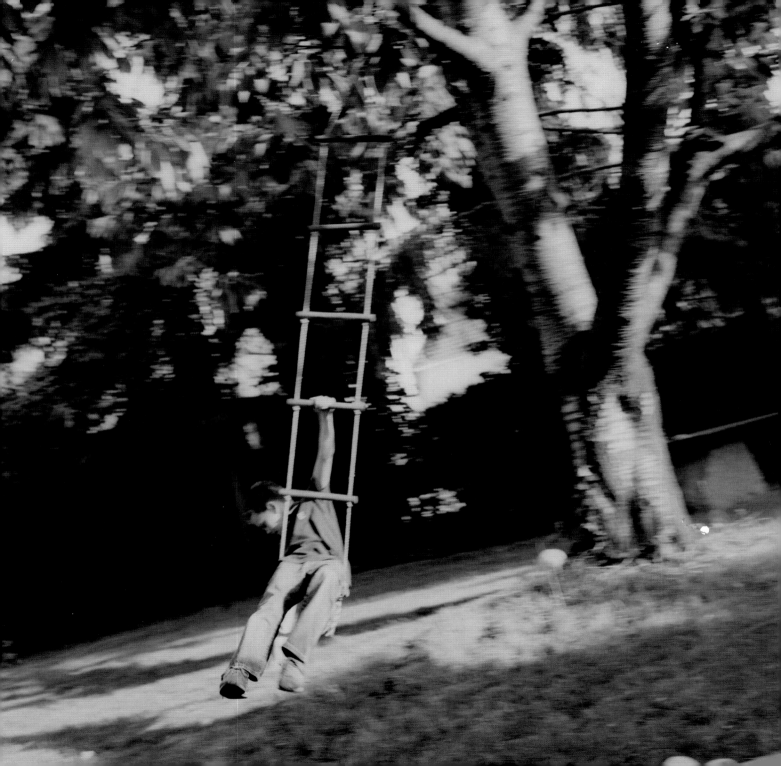

# What Is a Camera?

▲ This is a modern digital camera. You can see its round lens in the center.

A camera is a tool to take pictures, of course, but wouldn't you like to know a little bit more? A camera is really a simple device. It's basically nothing more than a little box with a lens attached to the front.

## The Eye of the Camera

The photographic lens is like the eye of a camera. It's made up of several small lenses like the ones used in eyeglasses.

The lens "views" an image and sends it to the sensor or chip, which is located inside the camera body. The sensor converts the image so the screen on the back of the camera can show a live image of what is in front of the camera's lens. The screen is sometimes called the *display*. When you press the shutter-release button, the image is captured and saved

as data on the memory card. The screen displays the newly captured image for a moment before a live image returns. This lets you see if your photograph turned out well.

Besides the lens, the shutter-release button, and the display, there are several other buttons and knobs that change the way your camera takes pictures. We'd like to explain the most important of those to you now.

▶ You can view all of the pictures you've already taken on the camera's display, which is found on the back of the camera.

# Now it's Time to Get Started!

Let's start at the beginning. We'll show you how things work with our camera, and since modern cameras are all similar, you'll be able to find the same settings on your camera. You should also study your instruction manual because that's where you'll learn about all of your camera's functions in detail.

First, place your hand through the wrist strap so you don't accidentally drop your valuable camera on the ground. Next, turn your camera on with the on/off button, which is sometimes called the power button.

Now the lens will extend from the camera body, and the screen on the back will display a live image. The knob on the top of the camera is used to switch between the camera's various automatic settings. To start, let's turn the knob to the green option called auto. Sometimes this selection is called *automatic* and other times just A. Every now and then, the automatic mode is indicated by a small green camera icon AUTO.

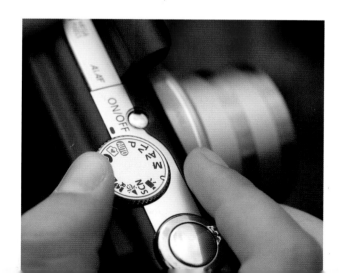

▶ The knob on the top of your camera controls the different functions and modes of the camera. You'll get the best results with auto. Next to the knob is the on/off button.

When you use the auto setting, a small computer in the camera makes all of the important decisions for you, so your pictures will almost always turn out well. The auto mode 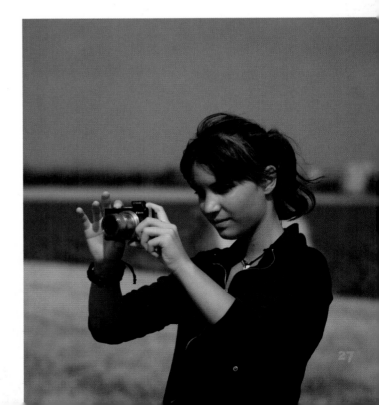 lets you start taking pictures right away, without any trouble.

When you're ready to snap your first photo, hold the camera very still—if you're unsteady, the image will be blurry. Press the shutter-release button until you hear a soft click, which means you've taken a picture. The screen will show the image you captured for just a few seconds. To view the photo again, press the *play* button ▶. Now you can use the arrow keys to scroll through all of the captured images saved on the camera.

When you want to take more pictures, switch back to the shooting mode. Some cameras have a special switch for this, but on ours you just press the *play* button ▶ again. You can tell that you're back in shooting mode if the screen displays a live image of what is directly in front of your camera's lens.

▶ To take a picture, press the shutter-release button all the way down. It's important to hold the camera very still.

**Tip** Today it's easy to take fantastic photos.

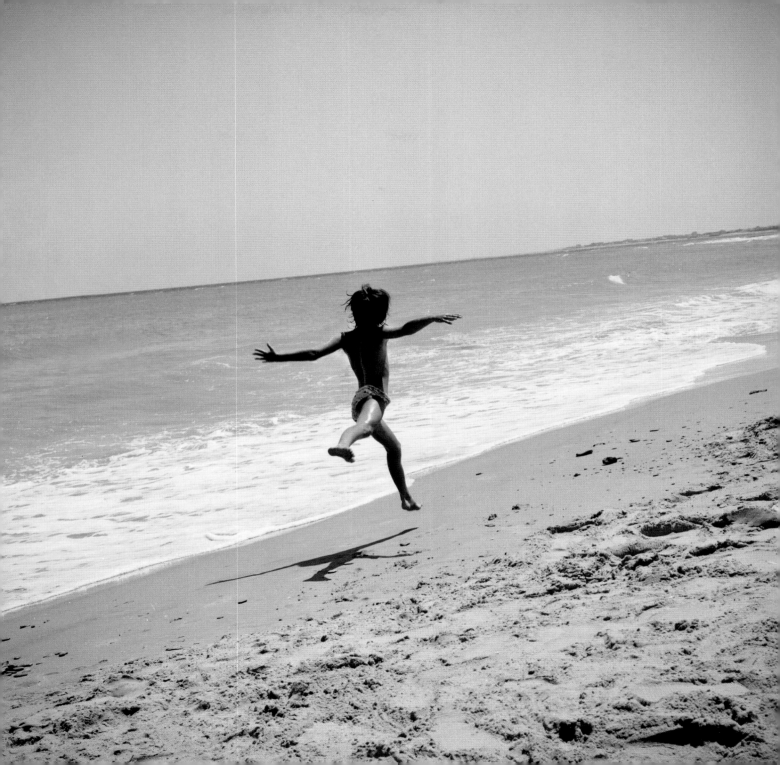

# Look, Snap, See

## Zoom

Now you've taken your first picture, and it's time to take a closer look at your camera. There is a rocker switch in front of the shutter-release button. If you move it to the right, you can make objects that are far away appear closer to you. When you do this, the lens extends from the camera. If you press the switch to the left, the images will become smaller. You'll be able to see more of what's in front of you because the lens retracts.

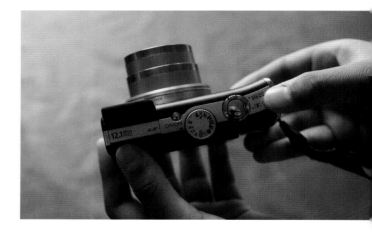

This function is called the *zoom*. You use the zoom function to determine what's in your picture. A *wide angle* ▦ allows you to take a picture of almost everything you see. A picture with a tight angle is called a *telephotograph* [▮]. This perspective allows you to pinpoint a specific detail in your picture, like someone's face, for example.

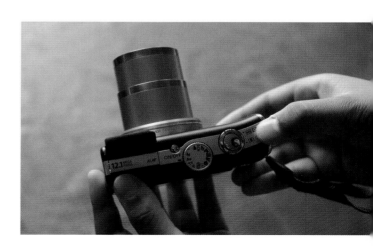

▲ With the wide-angle lens setting, your camera will capture a good deal of the scene.

▲ With the zoom lens setting, your camera will be able to capture more detail.

◀ Left: With the wide-angle setting the lens will be completely moved back into the camera body, while with the zoom setting the lens will be fully extended.

# Look, Snap, See

## In Focus and Out of Focus

Your camera has another important setting: the focus. We've all seen pictures that are unclear, and we usually want to avoid taking pictures that are out of focus. To make sure that your picture will be clear and sharp, you need to set the range of your camera's lens correctly. The range depends on the distance between you and the subject you'd like to photograph. Think about when you use a magnifying glass. You can see the object you're investigating clearly only if you hold the magnifying glass at the right distance. Binoculars work the same way; you need to adjust the focus to get a sharp view of your subject. When you use a camera, the lens is automatically set to the correct range by the *autofocus*. Though the autofocus is very good at setting the range for the lens, it cannot determine the most important subject in your picture.

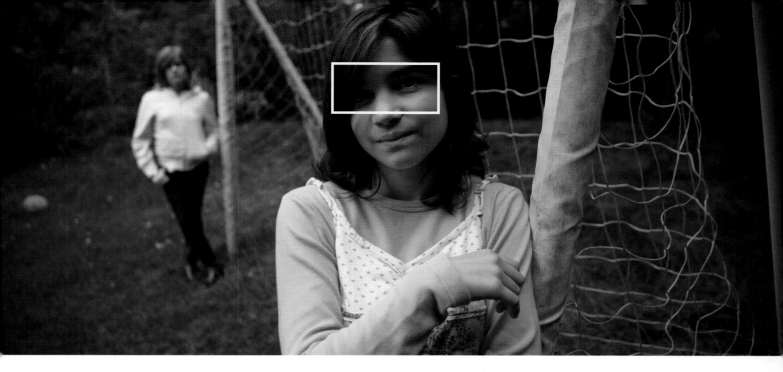

If you want to focus on your friend Anna, for example, the camera doesn't know whether to focus on her or the girl behind her. You have to make sure the camera is focusing on the right subject. To use the autofocus, press the shutter-release button halfway down—don't press it all the way down or you'll take a picture. As you do this, you'll see the image come in to focus on the camera's screen. A little box will indicate which object the autofocus has selected as the focal point of the picture. As long as you keep the shutter-release button depressed halfway, the autofocus will stay locked in on the same point.

Some cameras indicate that the focus is set in different ways. Depending on your camera model, the autofocus box may stop blinking, may change color, or the camera may beep to let you know that the image is in focus. If you're too close to your subject, or if you're trying to photograph something that is only one color, your camera might have a hard time focusing correctly.

# Look, Snap, See

## Light and Dark

You already know that photos are made with light, which means the amount of light plays a big role in how your picture will appear. If it's too dark or too light when you take your picture, you won't be able to recognize anything in the photograph. Cameras have a variety of automatic features that control light, and they'll usually help you take great pictures. But every once in a while a photo will turn out too dark or too light. When this happens, you can use the simple brightness correction feature ⊞. If you move the indicator toward the plus sign, the picture will become lighter. If you move it toward the minus sign, it will become darker.

35

# Look, Snap, See

## Movement

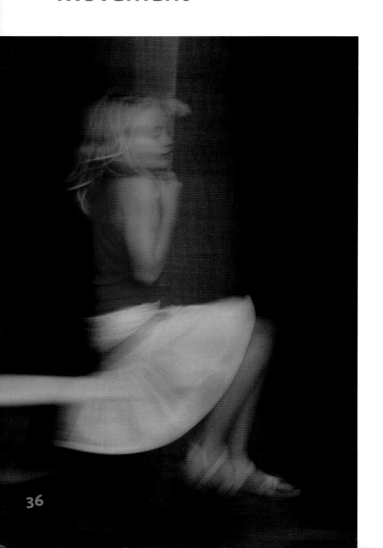

Sometimes pictures will be blurry even if you use the focus feature correctly, and you might wonder, "Why did that happen?" Remember, a photo is an exposure of a brief moment. When you press the shutter-release button, a shutter opens to let light shine on the sensor. When the light has been absorbed and the picture has been made, the shutter closes again. The whole process lasts only a split second. The amount of time that the shutter remains open is called the *exposure time*. The length of the exposure time depends mostly on how bright it is. If there is a lot of light, like on the beach, the exposure time is very short, but if there isn't much light, like in a basement, the exposure time is longer. When you take your pictures, you'll be able to hear the difference between a short and a long exposure. After you press the

shutter-release button, you'll hear a soft click, and a short moment later, you'll hear a second click. Everything that happens between those two clicks is photographed, and everything that moves during that time will be blurry. This is called *motion blur*. Moving animals and people, for example, will be out of focus. Shaking the camera during the exposure time will also cause the picture to be blurry. We call this problem *camera shake*.

Most of the time we want to take pictures that are in focus, but sometimes motion blur can create interesting and vivid images. Give it a try! It can look really cool when you track a moving object during a long exposure. If you really want to avoid motion blur or camera shake, the camera's built-in flash is there to help you.

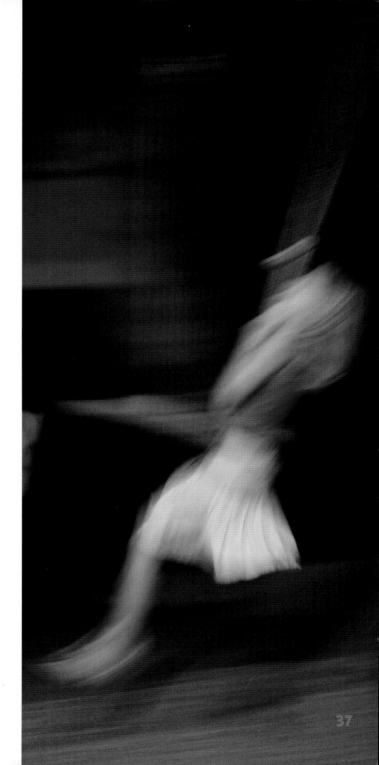

# Look, Snap, See

## Flash

There are a few switches and buttons near the display, and one of them has a symbol that looks like a small lightning bolt ⚡. This button allows you to turn the built-in flash on and off. The flash is actually just a small, strong light bulb that illuminates your subject just long enough for the camera to capture an image. It's just like a flash of lightning that illuminates the night sky for a brief moment. The flash setting that you selected can be seen in the display where you check the camera's other settings. There are usually a few flash settings to choose from. An icon that shows a person with a small star 🌃 indicates the night flash mode, which gives off less light and has a longer exposure time. You can use this setting to create cool effects.

A lightning bolt with a slash through it ⚡ indicates that the flash is turned off, which is something you'll want to do from time to time, because the flash's harsh light doesn't always make interesting pictures. It's best to use natural lighting, but if you have to use a flash, try the night flash setting 🌃.

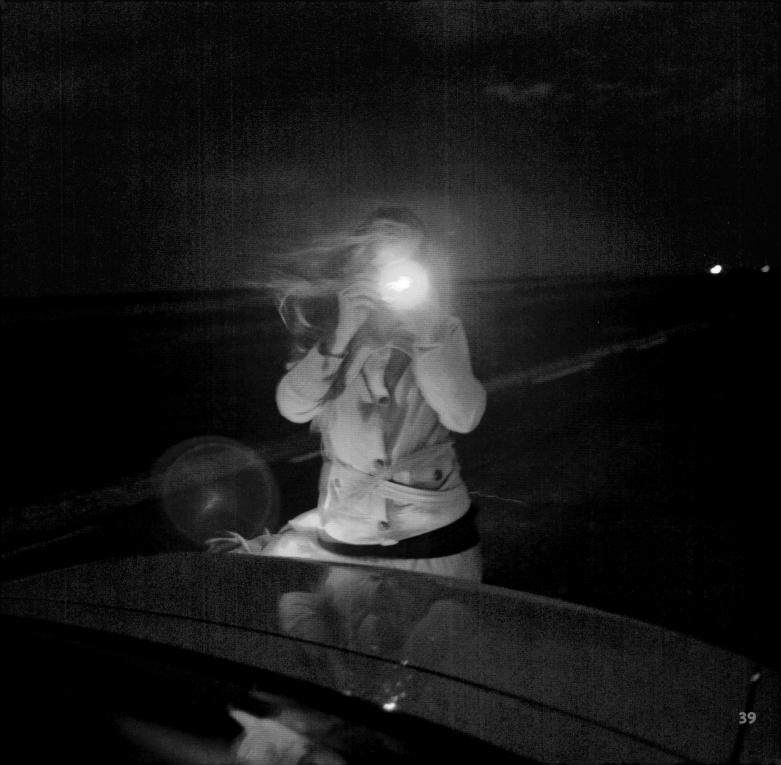

# Look, Snap, See

## For Small Things

The setting with the small flower symbol 🌷 allows the lens to focus on objects that are very close. This mode is called *macro*, and you'll need it when you want to focus on small subjects, like a ladybug, at close range. A flower symbol 🌷 will appear on the screen to indicate that you're in macro mode. When you feel like exploring the world of small things, choose this option. Just don't forget to exit out of macro mode when you're finished, otherwise you won't be able to take pictures of normal-sized, larger objects.

Now you know quite a bit about your camera, and you're able to take pictures just like professional photographers. But you might be wondering, "What am I going to do with all these new pictures that I've collected on my camera?"

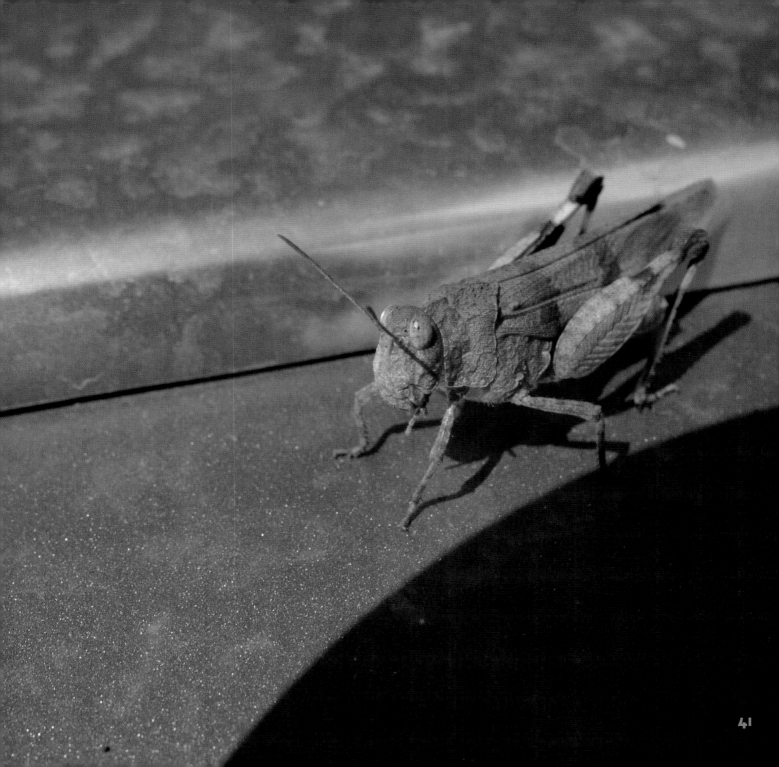

## Look, Snap, See

## How Do We Transfer Pictures to a Computer?

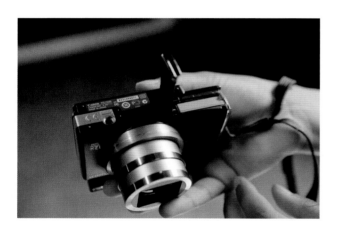

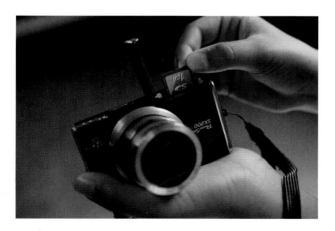

Sooner or later you'll want to see what your pictures look like on a screen that is bigger than your camera's small display, and you may even want to print some of your favorites. To do this you'll need to transfer your pictures from your camera to your computer. This is easy to do. You've probably seen someone else do this, but be sure that someone who has experience with computers is there to help you. The camera will either need to be connected to the computer with a cable or the memory card inside the camera will need to be removed and inserted into a card reader. After this is done, you can save the pictures onto your hard drive with just a few clicks.

◀ ▲ Underneath a small flap you'll find the battery and the memory card.

That's all there is to it. You can use a special program called a *picture browser* to view your photos on your computer monitor. There are several free picture browsers on the Internet—like FastStone, XnView, or Picasa—that you can download for free. These programs will let you organize your pictures easily.

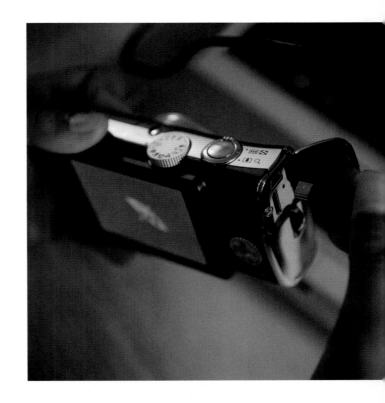

▲ ▶ You can connect your camera to your computer with a USB cable, or you can remove the memory card from the camera and insert it into a USB card reader.

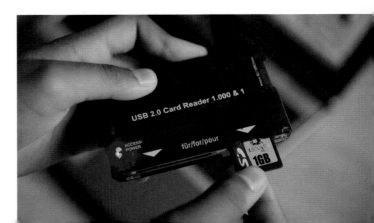

# A World Full of Subjects for You

Now you know everything you need to take amazing pictures. But what should you photograph? In the next few sections we'll give you some suggestions so you can discover the world through your camera. You can, of course, take pictures of anything you find interesting or beautiful, but there are a few common subjects that photographers love to capture. Many photographers find people to be the most interesting subject. One reason for this might be that people are always changing and doing new things, and cameras allow us to capture these changes.

Many of us also like to take pictures of beautiful landscapes, like mountains or the ocean. Others like to photograph small and large animals. In any case, your pictures won't always fall into one category. If you take a picture of someone in a green meadow in front of a breathtaking mountain range, the picture is just as much a portrait as it is a landscape photo. And a picture of your little sister holding a cute kitten in her arms is a picture of both an animal and a person. Don't get caught up in the details; just take pictures of everything that is interesting to you.

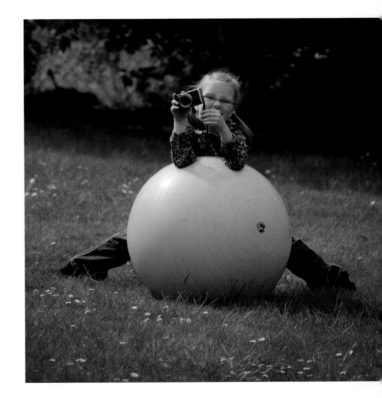

Here are a few extra tips for taking great pictures, which are useful for all kinds of photos:

- When you're outside, the best light for photography is in the morning and evening. During the middle of the day when the sun is high, the light isn't all that interesting. You can see the details of your pictures best during morning and evening when the sun is low in the sky.

- Get up close when you're taking a picture of a person. You shouldn't have to look at a picture twice to recognize who's in it.
- Don't try to cram too much into your pictures. Concentrate on the main subject.
- Pay attention to the details in the background of your picture. Plants and other objects can be distracting if they're directly behind a person. It might look like a flower is growing out of someone's head!

**Tip** Bring your camera with you whenever you can, not just in situations when it seems normal to have one. The more you have your camera handy, the more opportunities you'll have to capture unusual events. If you happen to have a cell phone with a camera, it will also do in a pinch.

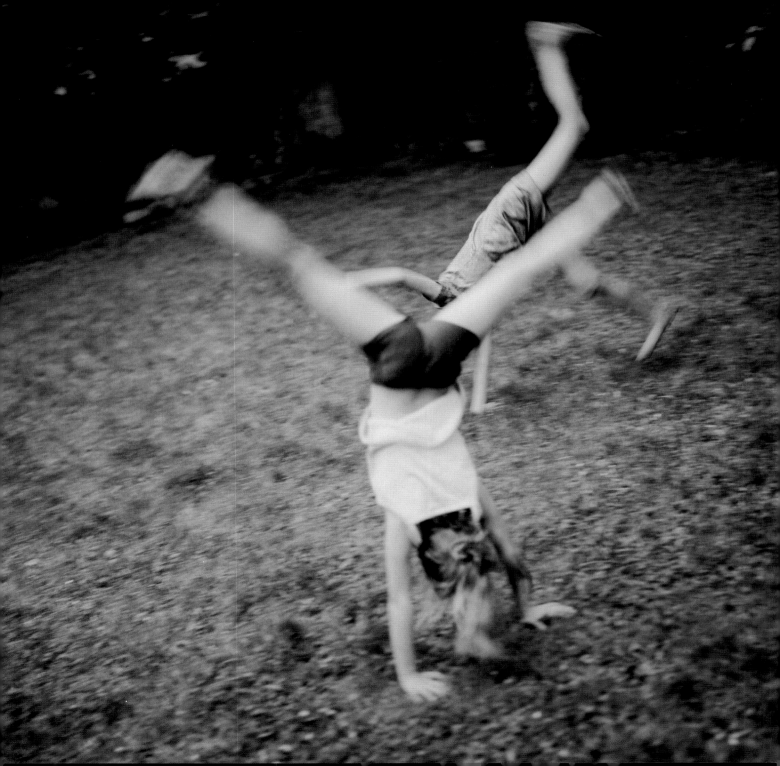

# Take a Picture of Me!

Your best memories are probably times that you've spent with your friends. Life would be boring without them. You can count on friends when you need a hand, and some friends will be with you forever. Pictures are a great way to remember the people who matter most to you. When you're older these pictures will be very special. Events like basketball games or piano recitals are great opportunities to take pictures of your friends. You might even be able to make new friends through photography. The next time you have a chance, ask someone nice if you may take his or her picture and, who knows, it could be the beginning of a long friendship!

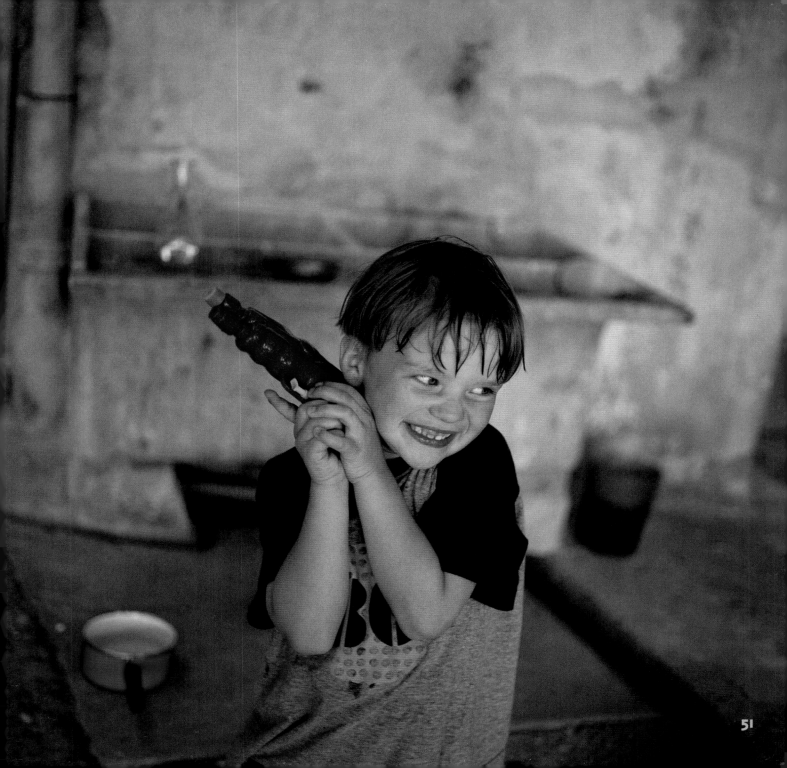

**Tip** Take pictures of your best friends and hang them up in your room so you'll always be reminded of them.

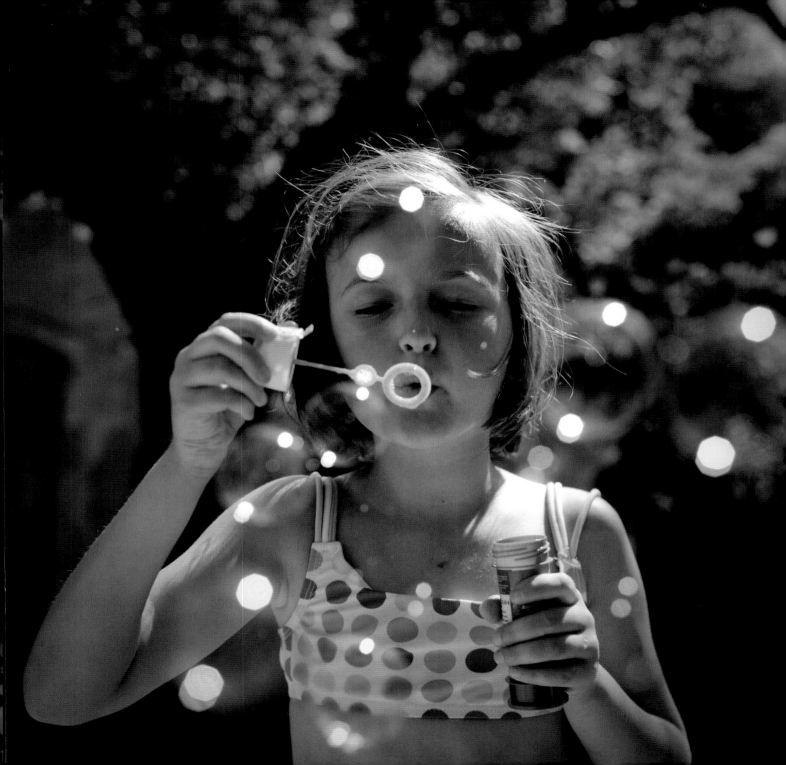

# Everyone Loves Animals

Animals are some of the best subjects for great pictures. They have many interesting qualities that fascinate us: they are funny and sweet, exciting and strange, and sometimes they are wild and dangerous. Animal photographers travel to the distant parts of our world to take amazing pictures of animals that we see in newspapers and books.

There are a few things to keep in mind when you're taking pictures of animals. Some animals are really dangerous, so if you come across a lion or a crocodile, keep a safe distance and use the zoom to take a telephotograph 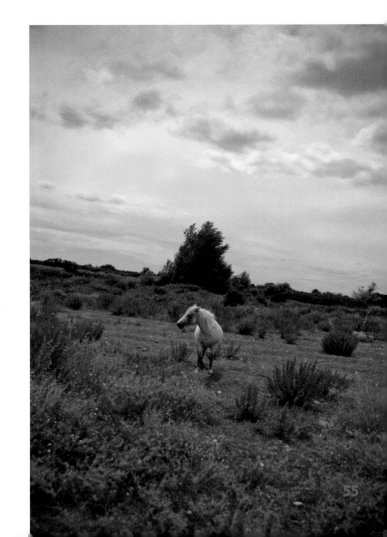. The same goes for unfamiliar dogs, but fortunately most animals are not that dangerous and not that big. You don't have to travel to Africa to take pictures of animals; you can take great pictures right here at home.

# Everyone Loves Animals

## Four-Legged Roommates

Your first experience photographing animals will probably involve your own cat, guinea pig, or parakeet. If you don't have a pet, ask if you may take pictures of a friend's pet.

Cats are gifted acrobats. Try to catch them jumping over a wall or climbing a tree. Use your zoom [▲] so you can stand at a distance to watch these little predators hunt their prey. Cats are fascinating indoors, too. You can watch them battle with a ball of yarn or hunt a line of thread for hours.

As you take pictures, try shooting from different vantage points: stand on a sturdy chair to take pictures from above, or kneel on the ground to take a picture at the level of the animal's eyes.

Dogs are also exciting subjects for the camera. They'll go to great lengths to fetch a sock for their master; they might leap into the air and perform breathtaking stunts or even jump into a lake or a pond! Back on land, they'll shake vigorously, and water droplets will fly everywhere. This is a great opportunity for pictures and—if it's hot out—for cooling off. Just be careful that your camera doesn't get too wet.

It's a good idea to take lots of pictures when photographing animals so you can select the best ones later. Animals have lots of energy, and they tend to move around constantly, so many of your pictures may be out of focus. Have a friend help you when you take pictures of animals. That way your friend can handle the animals and you can stay focused on your camera.

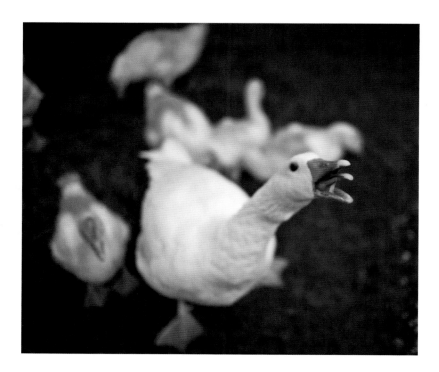

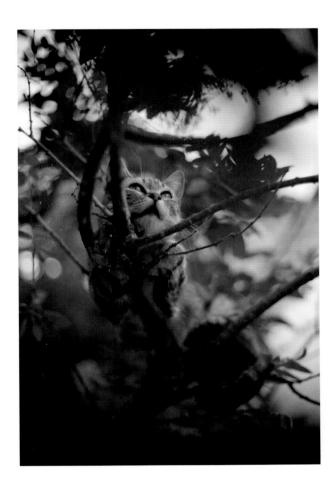

◄ ▼ No matter what your subject is, be sure to try different perspectives. Take pictures of animals from above, as with the goose and the dog, and from below, as with the cat.

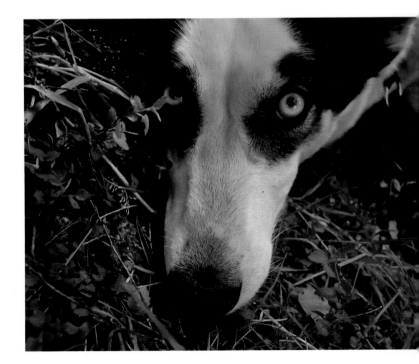

# Everyone Loves Animals

## Animals Are Everywhere

Our four-legged roommates aren't the only animals we can photograph. You can find animals all over: horses and cows grazing in the pasture; ducks and swans swimming on the pond; chipmunks jumping back and forth in trees; pigeons bathing in fountains; and colorful butterflies resting on flowers. Animals really are everywhere!

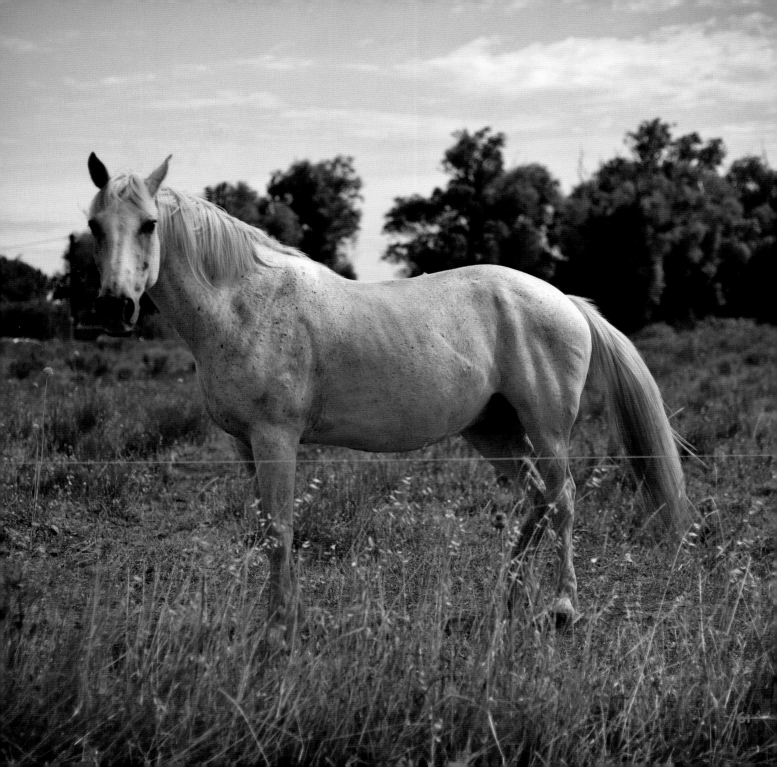

**Tip** Challenge yourself to take a picture of every animal you see for an entire day. You'll be surprised by how many you find.

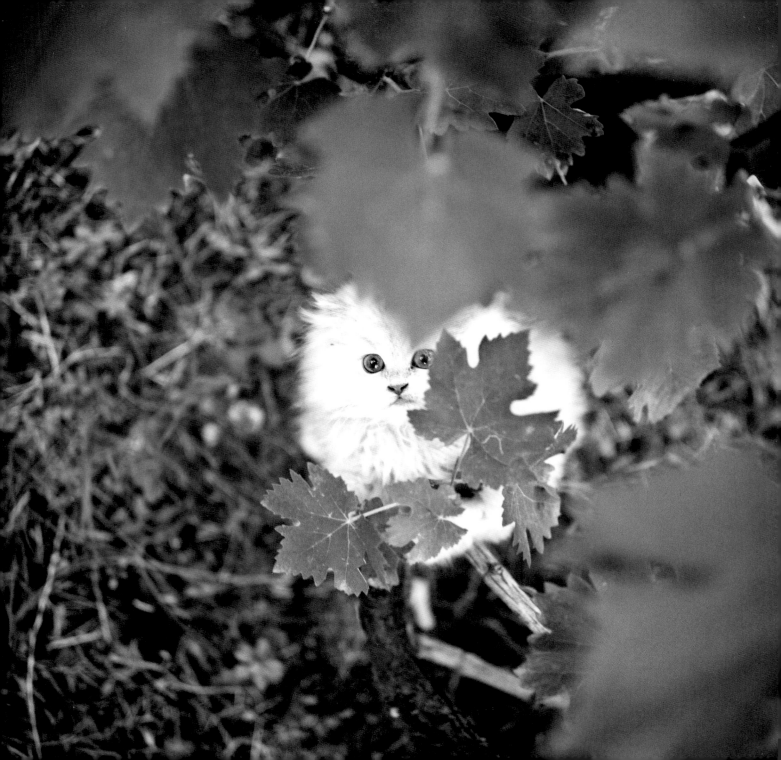

# Around the World in an Afternoon

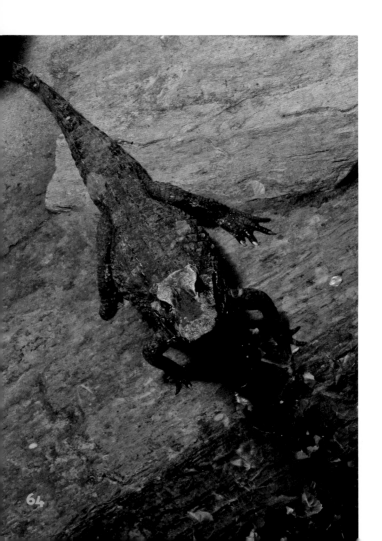

If you go to the zoo, definitely remember to bring your camera. It would be tough to find a better place with so many great opportunities for photographs. It's like you're taking a quick trip around the world—one minute you're observing African lions slumbering in the sun, and the next minute you're watching arctic polar bears taking a swim. Turn around again and you might see amusing meerkats in a huddle just like a football team or pink flamingoes standing on one leg as still as statues while all the visitors pass by. All of these scenes are begging to be captured in a photograph. Modern zoos use less and less fencing to enclose their animals, so with a little luck and creativity, your pictures will look like they were taken in the wild.

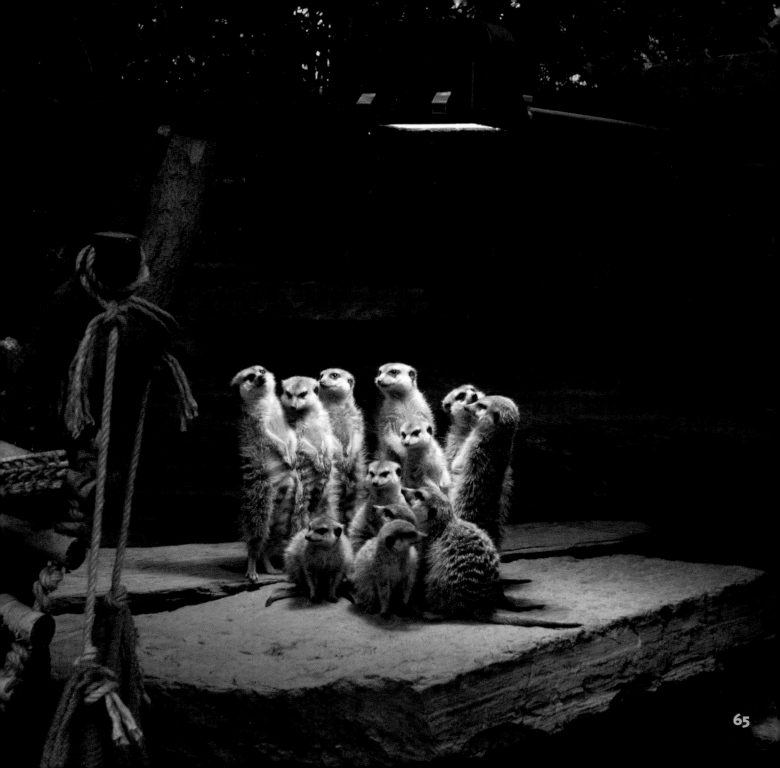

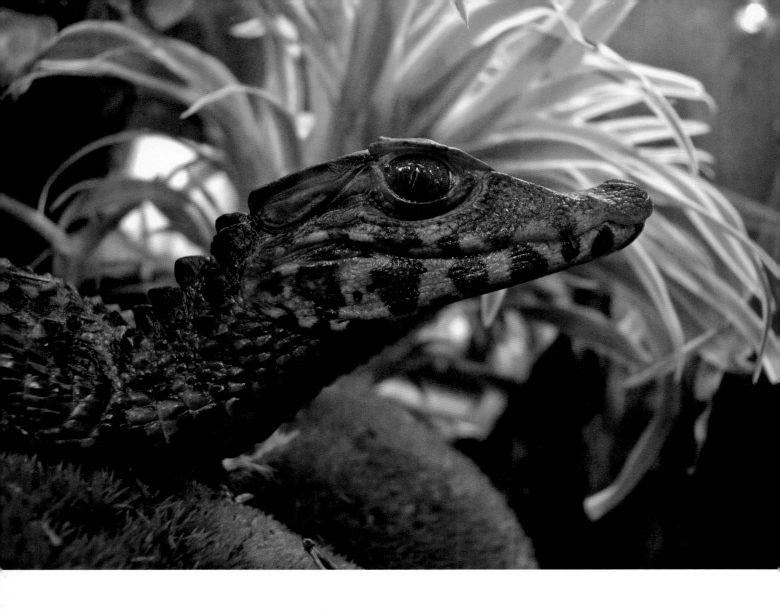

Use your telephoto zoom [📷] so you can get rid of distracting objects in your picture's background. You can also use the telephoto setting on your camera to capture a picture of a crocodile's eye or a tiger's tooth.

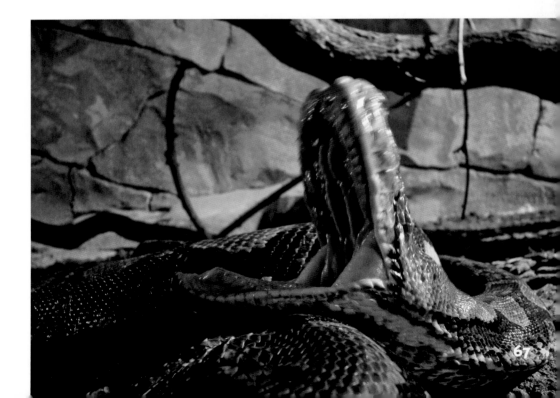

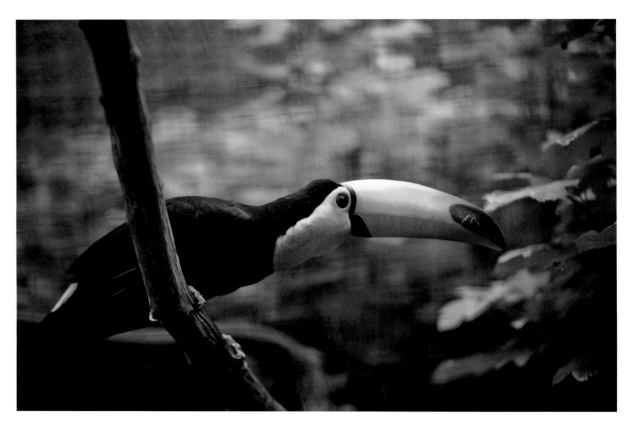

▲ ▶ If you put your camera right up against an animal's enclosure and make sure to focus on your subject, the fence will be blurry and won't be too distracting. (Always be sure not to break any zoo rules and keep safety in mind!)

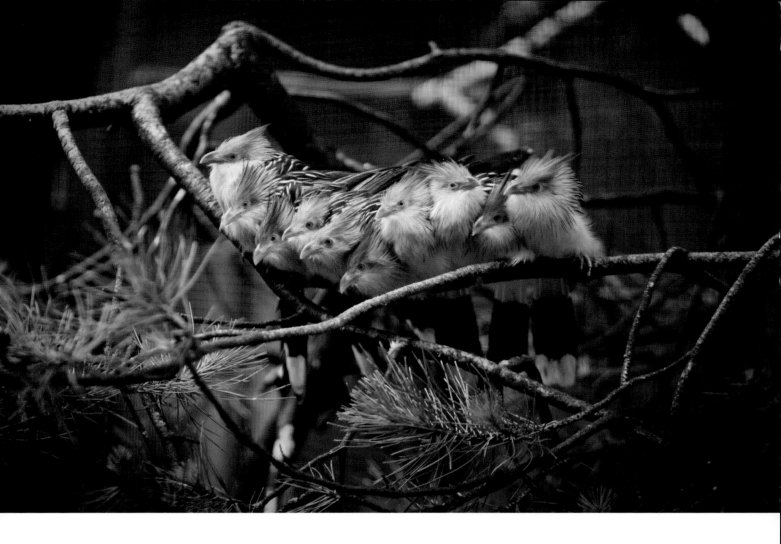

# Around the World in an Afternoon

## Face to Face with Sharks and Squid

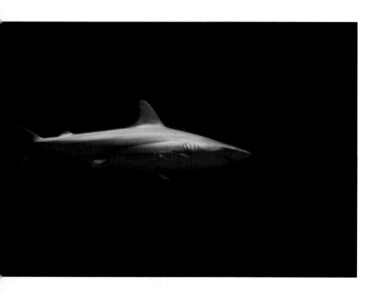

Taking photographs in an aquarium can be a real challenge because you'll often see your own reflection in the glass walls of the tanks. But the underwater world is really a treat to photograph. There's no other place where you can take pictures of fish, sea snakes, jellyfish, and sharks. One good trick is to get as close as you can to the glass—so close that your lens touches the tank. Be sure to turn off your flash so it won't be reflected or disturb other visitors. After you give this a try, you'll see that you can take amazing pictures of the colorful and mysterious world beneath the sea.

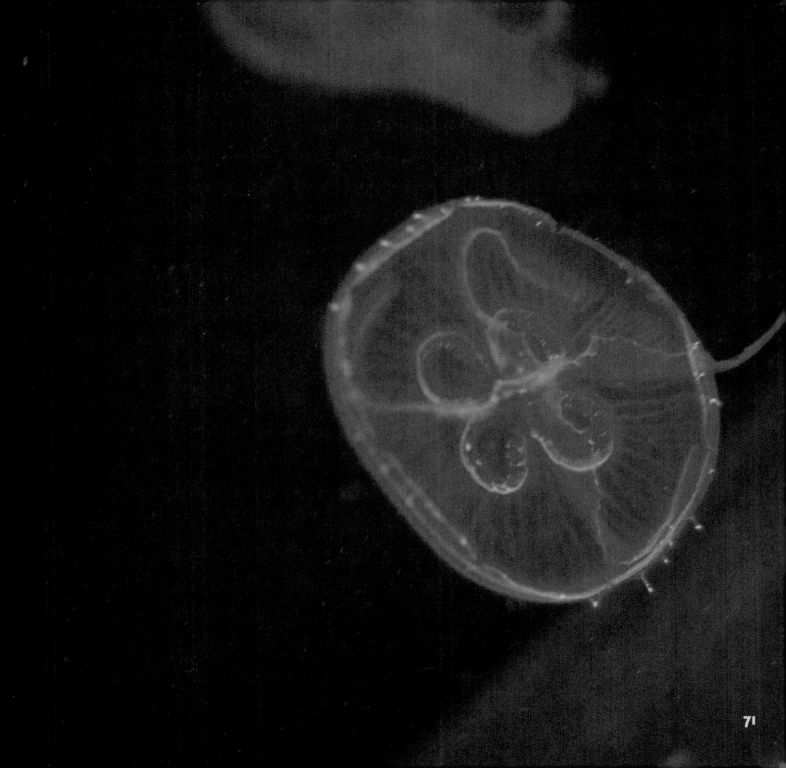

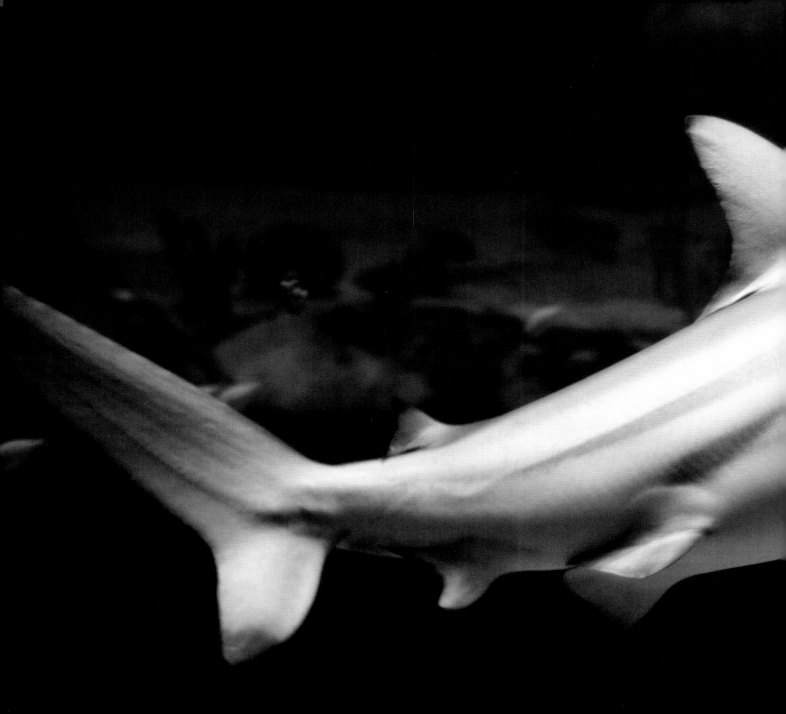

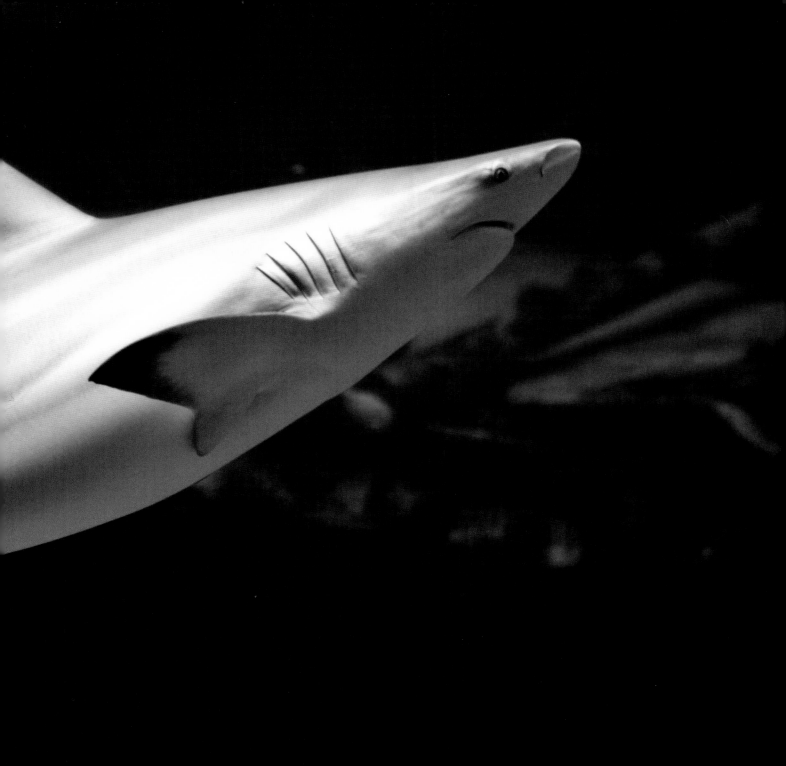

# Around the World in an Afternoon

## People and Animals

Sometimes the people who visit the zoo are just as interesting as the animals that live there. Use your camera to observe little children pressing their faces flat up against the animal enclosures. It's also fun to watch the animals react to the visitors. Apes, for example, will sit still for a long time, observing people outside their habitats. If you're able to take a picture that shows a person beside an animal, the results can be really funny—sometimes the people start to resemble the animals, and the animals start to look human.

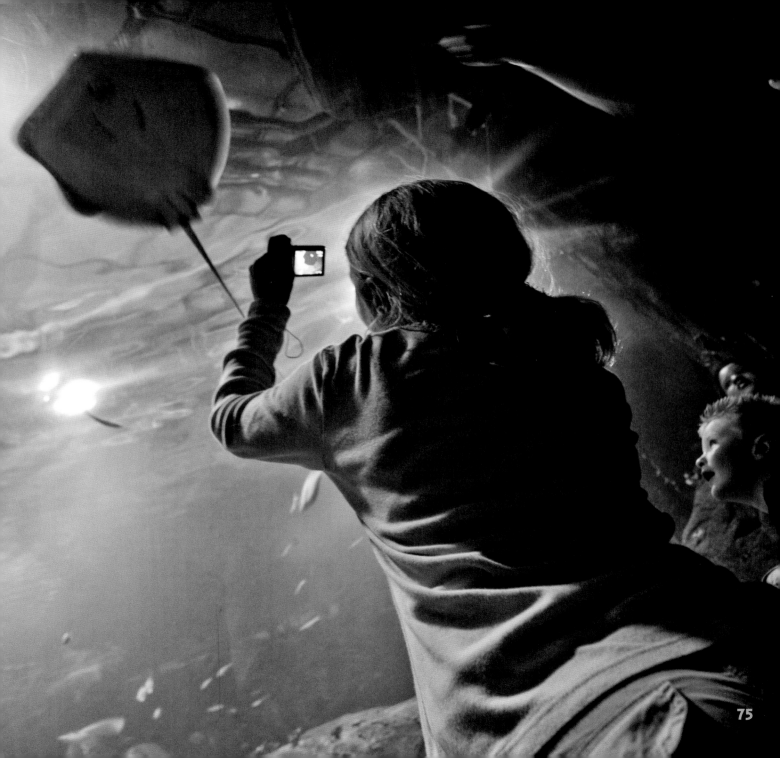

Some animals might have feeding times during your visit, or if you're lucky, you may even get to give them a treat yourself. You shouldn't pass up this great opportunity, even if you don't think watching a rattlesnake devour a mouse is your cup of tea. Most animals eat calmly. It's fascinating to watch elephants skillfully pick up carrots with their trunks.

# Pictures without Color?

The world is colorful: bananas are yellow, grass is green, and fire trucks are red. You've probably seen many photos (some of them in this book) that are in *black-and-white*, and you may have even seen movies filmed in black-and-white. Why do we have black-and-white pictures? Here's the simple answer: when photography was invented, it wasn't possible to take pictures in color. When color photography was invented, it was a time-consuming and expensive process, so photographers continued to take pictures in black-and-white for a while. This is one reason people think black-and-white pictures are beautiful and why many modern cameras can still take black-and-white pictures.

◀ This picture works well in black-and-white because the shapes and the composition are what make this an appealing image.

► This picture wouldn't work well in black and white. It would be boring because color is it's most important feature.

# Pictures without Color?

## Black, White, and Delightful

People like black-and-white pictures, but that's not the only reason we have black-and-white photography. Sometimes color takes away from what we're trying to show in a photograph. Interesting patterns, textures, and shapes show up better in black-and-white, and so do objects that cast fascinating shadows. In these cases, color isn't essential to a photograph, but other times it is. Use color photography when you want to capture the vivid details of a subject or scene.

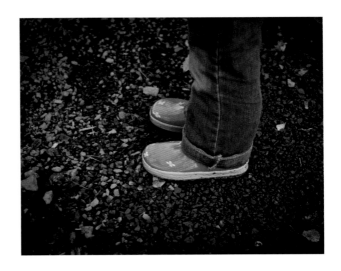

▶ This picture doesn't work well in black-and-white, since color is its most important feature.

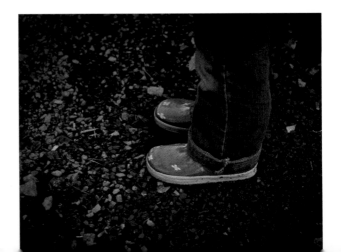

▼ ▼  In this example the bold green background detracts from the subject, therefore the image is stronger in black-and-white.

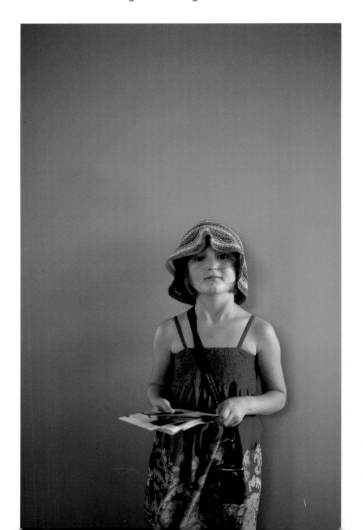
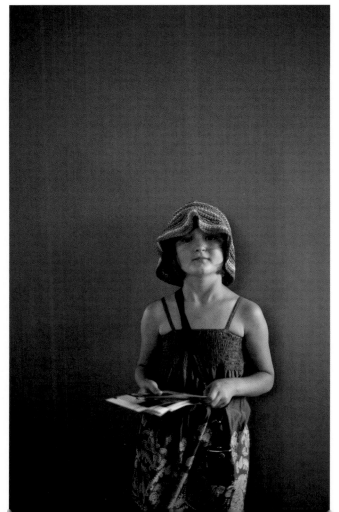

Try this experiment: Take pictures of an object both in color and in black-and-white. Then compare the results and decide for yourself which looks better. Also take pictures of subjects that you think must be captured either with or without color. A bright red ball on a blue ocean wouldn't look nearly as interesting in black-and-white.

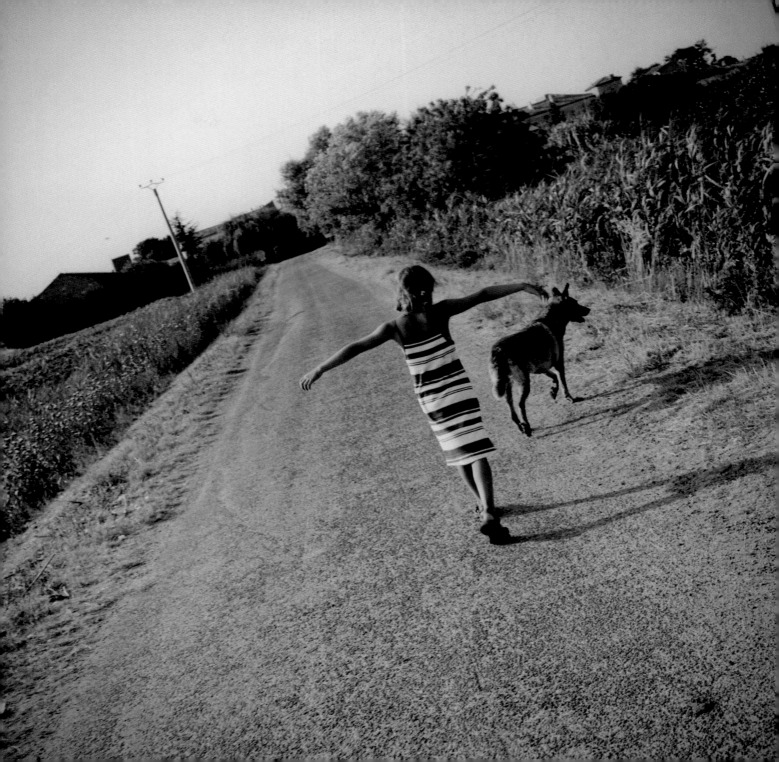

# Making Small Subjects Look Bigger

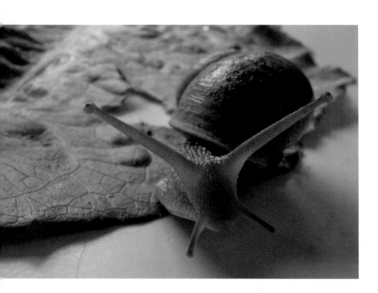

What does the fabric of your jeans look like? Do flower petals have small hairs? What is reflected in a dewdrop? What does a dragonfly's wing look like? You can capture all of these things in a photograph with the macro setting 🌷. Macro mode allows you to take photographs of small objects so they look bigger. You're already familiar with the macro setting on your camera, so when you want to discover the world of small things, switch your camera's mode to the setting with a little flower 🌷 on it. You can zoom in on anything, including small animals like insects, but there is a limit to how close you can get to your subjects.

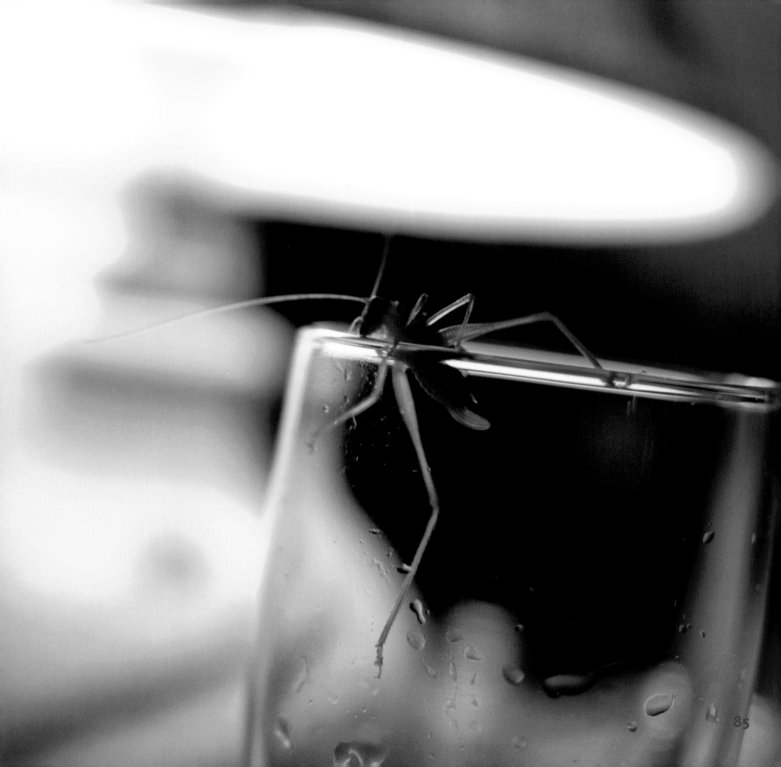

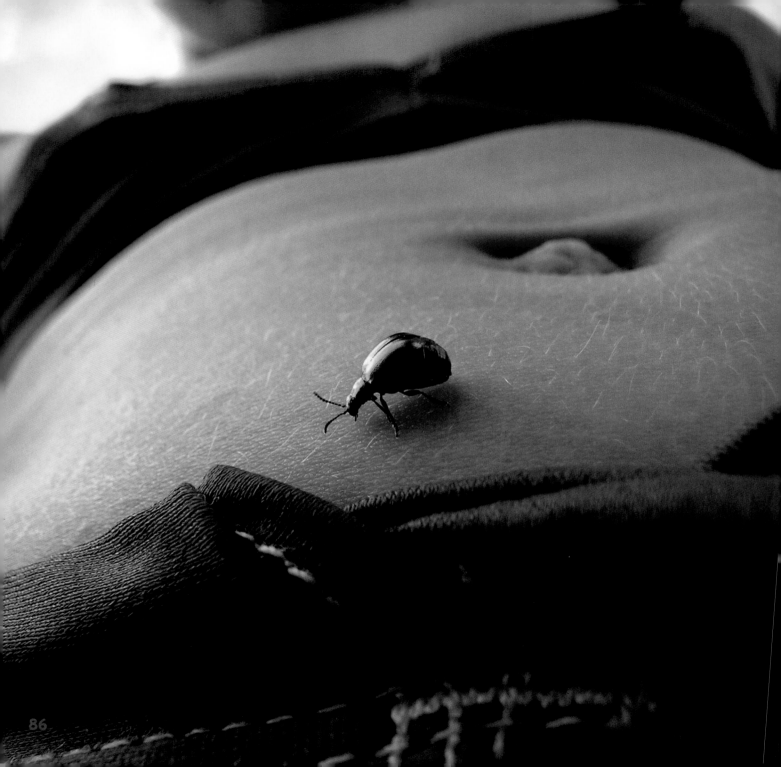

This *minimum focus distance* depends on your camera, but you can easily tell when you've reached it. If the camera can't automatically focus on your subject, you're too close to it. When this happens, move away from your subject just far enough so the autofocus indicator appears again. If you experiment with this feature, you'll get the hang of it.

Try taking a closeup picture of a small part of your favorite toy. You'll know exactly what you photographed—the hood of a model car, a part of a Lego block, or a flower on a doll's T-shirt—but other people will have to guess to figure out what it is. The shapes and colors of closeup pictures can result in beautiful and interesting designs.

Insects are great subjects for the macro mode, such as butterflies with their beautiful markings or busy bees crawling across flowers.

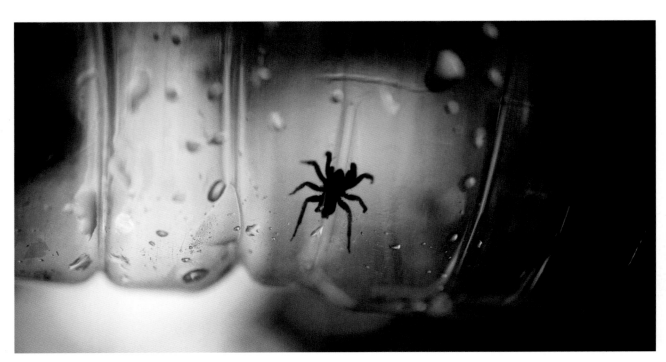

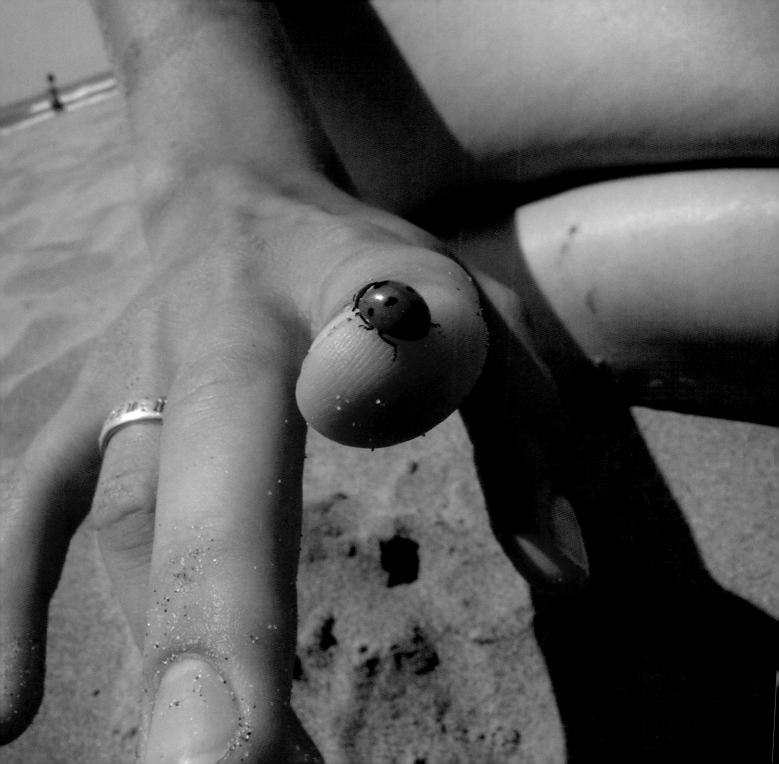

You have to be fast to take a picture of anything that flies. Fortunately, lots of moths aren't bothered by photographs, and they'll sit undisturbed so you can take a whole series of pictures. Be careful any time you take pictures of an insect that can sting!

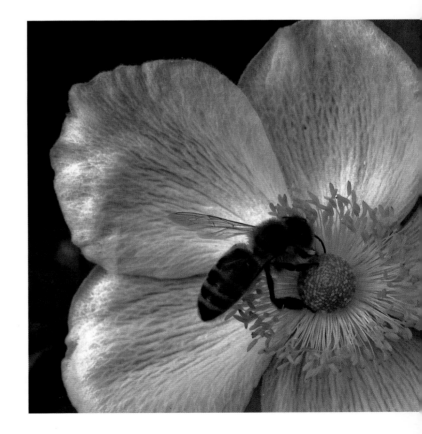

The flash won't be much help when you're using macro mode. It's too bright for objects that are right in front of your lens, so it won't illuminate your subject properly. It's important to be extra still when using macro mode because the closer you get to an object, the greater the risk that camera shake will ruin your photo.

# Vacation:
# Tons of Time for Cool Pictures

Imagine this: school is over and your bags are already packed. It's vacation time! You don't have to worry about schoolbooks and homework for a while, and you're ready to take a trip with your family. Any time you travel to a foreign place it's fun to observe new scenery, like great beaches and palm trees, snow-covered mountains, or green meadows as far as the eye can see. In unfamiliar places there are lots of new things to discover with your camera: exotic markets with items that you've never seen before, strange animals and plants, and interesting people with unusual clothes. These are all perfect subjects that are just waiting to be captured in a picture. So jump right in to this new world and take pictures to your heart's content.

# Vacation:
# Tons of Time for Cool Pictures

## Not Everyone Likes to Be in Front of the Camera

Be courteous when you take pictures of people because it's not polite to take pictures of strangers in some countries. Talk with your parents about the customs of the place you're visiting. If you're still not sure, it's always better to ask permission before you take a picture of someone you don't know. You can try to communicate with gestures if you don't speak the local language. You'll probably find that most people don't mind the attention of your camera, and some may even be flattered by it.

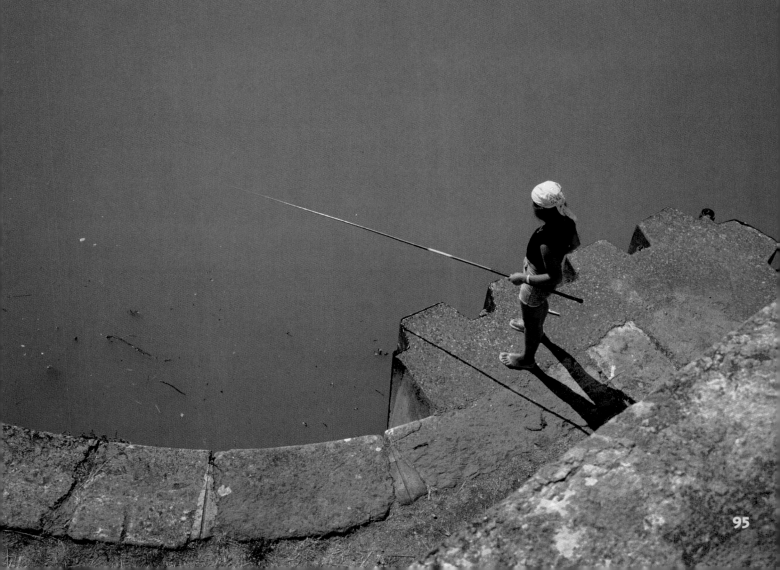

# Vacation:
# Tons of Time for Cool Pictures

## Taking a Vacation at Home

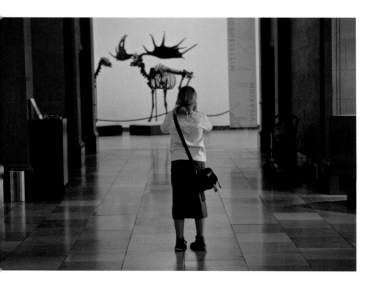

Even if you spend your vacation at home, you'll have many great opportunities to take pictures and explore the world around you, like at a swimming pool or a museum. Many museums don't allow flash photography, but you can usually take pictures if you turn the flash off ⚡. This is to protect valuable works of art that can be damaged by too much exposure to light. Ask a security officer or someone at the front desk if the museum allows photography. Generally, you won't run into any problems taking pictures in natural science museums, where dinosaur skeletons and stuffed animals don't mind having their pictures taken. Summer camp is another place to capture interesting and meaningful pictures.

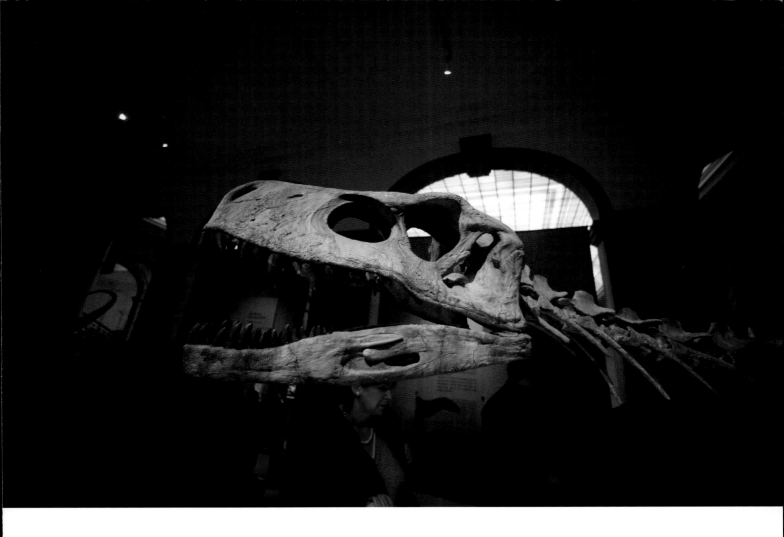

During the summer, many youth centers offer photography classes, where you can pick up some more great information about taking pictures.

If you go on a trip, try to tell a story through pictures. Start with pictures of your family packing suitcases and loading up your car, and include pictures showing your travel route on a map or your car's GPS. Try to capture every stage of your vacation. Before your trip, it might be a good idea to make a list of pictures you'd like to take, like dad carrying suitcases, mom sleeping in the car, highway signs with the name of your destination, your hotel room, and so on. After you take the picture, you can cross it off your list. Keep a watchful eye for subjects that you hadn't planned to photograph, like a beautiful view at a rest stop.

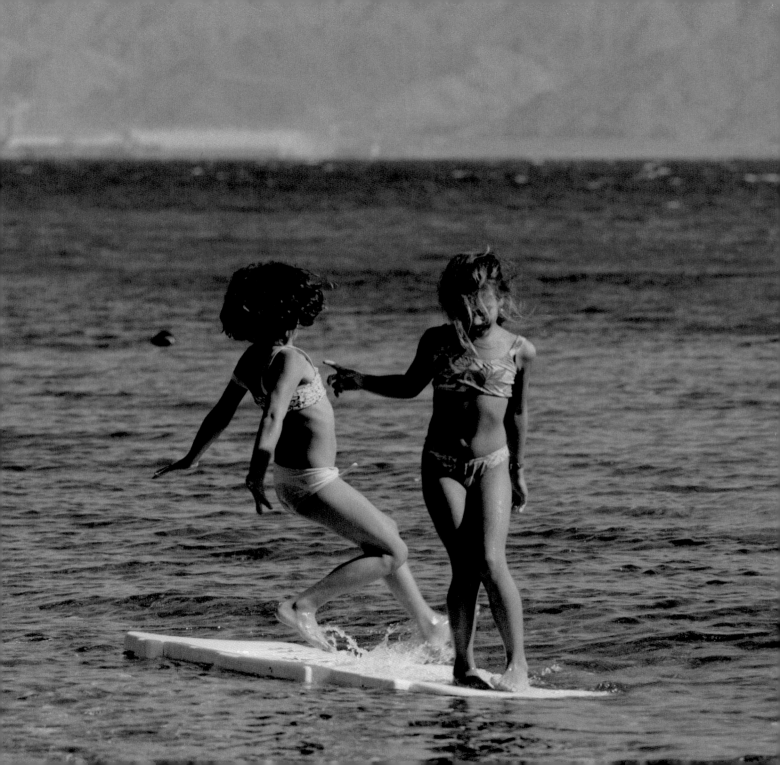

# Bring Your Camera along for a Swim

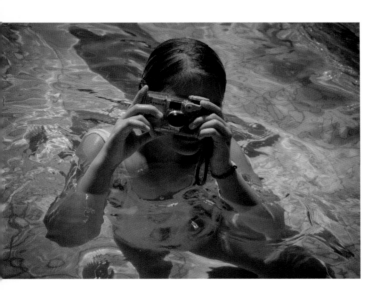

Cameras can't swim; they'll break in the water. Fortunately there are cameras that are watertight so you can take them into a pool or an ocean without any problems. Dirt, rain, and mud can't harm these cameras either, so they're perfect for any outdoor adventure. If you don't want to spend a lot of money on this kind of camera, you can find disposable waterproof cameras at drug stores or photo shops. These cameras use film, which needs to be developed, but they're much less expensive than waterproof digital cameras. As the name "disposable" implies, you can only use these cameras until the film is all used up.

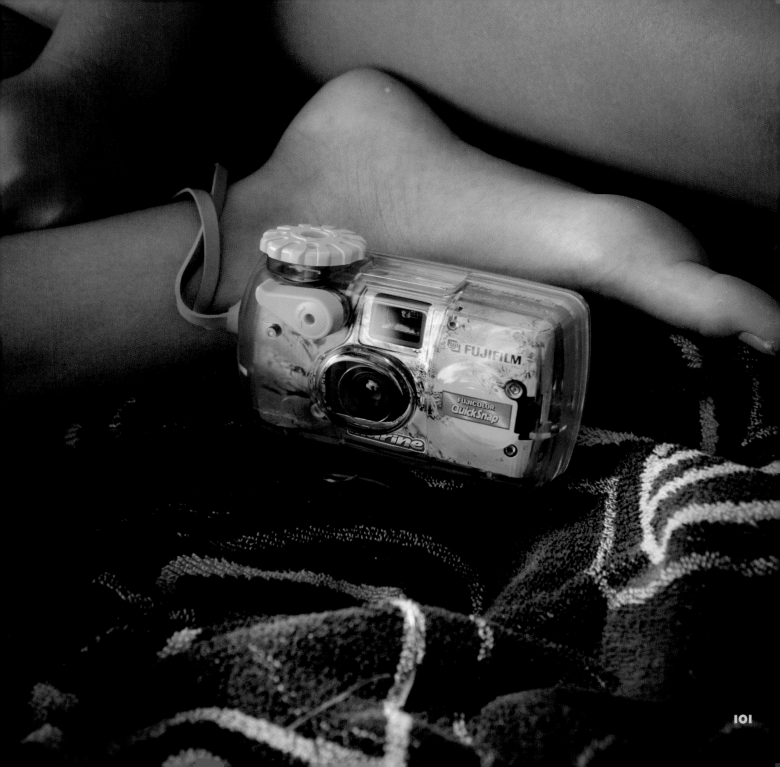

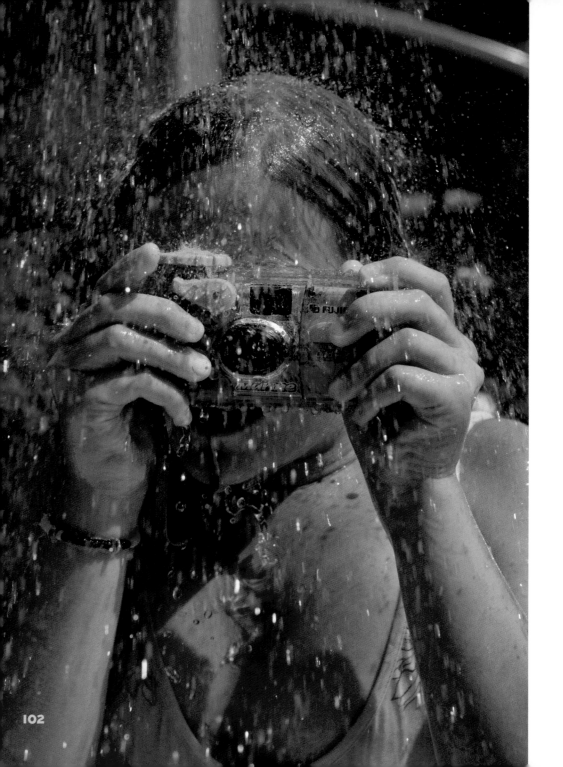

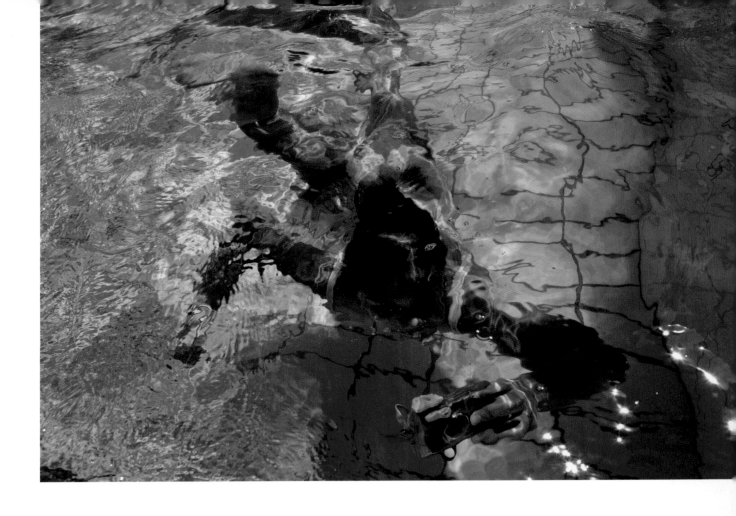

◀ ▲ Taking pictures with a waterproof, one-time use film camera can be a lot of fun and you can get really creative.

# Bring Your Camera along for a Swim

## There's a Lot to Explore at the Edge of the Pool

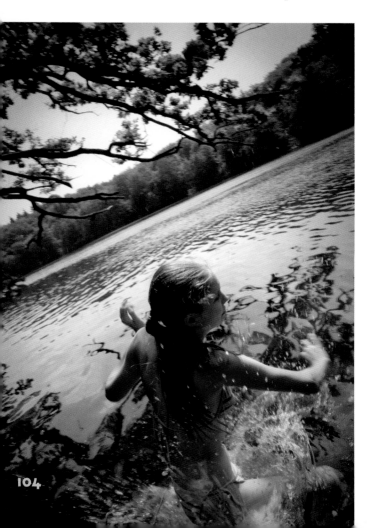

Even if you don't have a waterproof camera, the swimming pool is a great place to take pictures. There might be a courageous diver springing from the high-dive board, or a bright air mattress floating in the blue water. There are also exciting subjects to discover and photograph near ponds or at the beach, like small crabs or other creatures that are washed up on the shore.

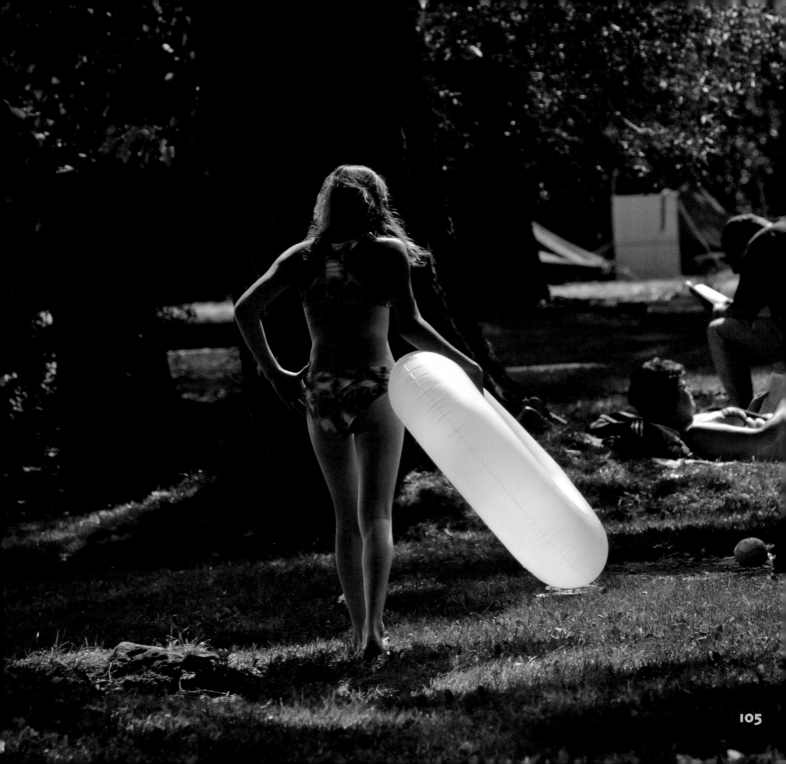

Take underwater portraits of some of your friends and have others guess who is in each picture.

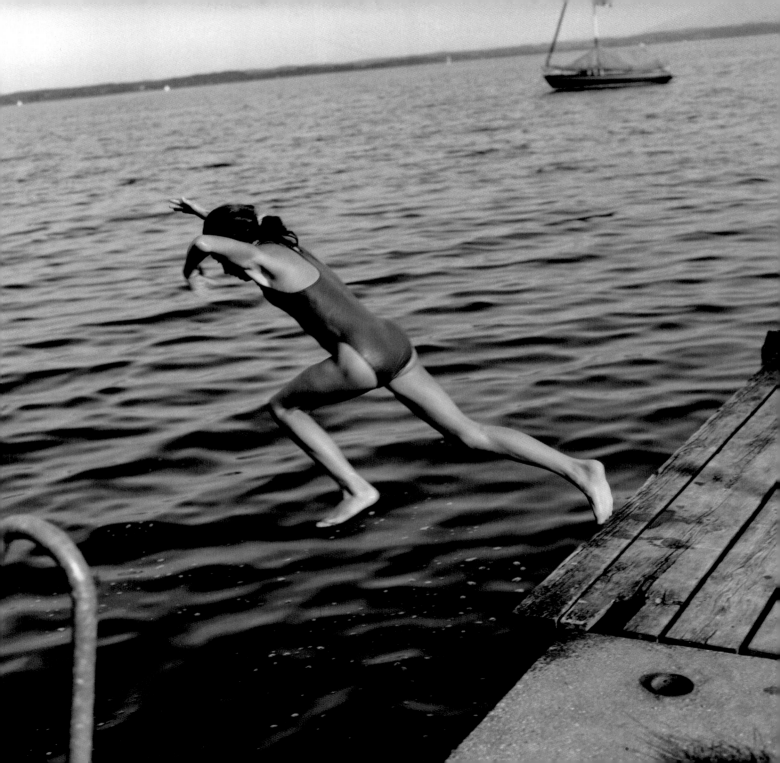

# A Sea of Moving Lights

Visiting a carnival can be a real treat for your nose, ears, and eyes—the smells of cotton candy, corndogs, and popcorn; the frenzied sounds of music coming from every direction; and the whirl of speeding rides.

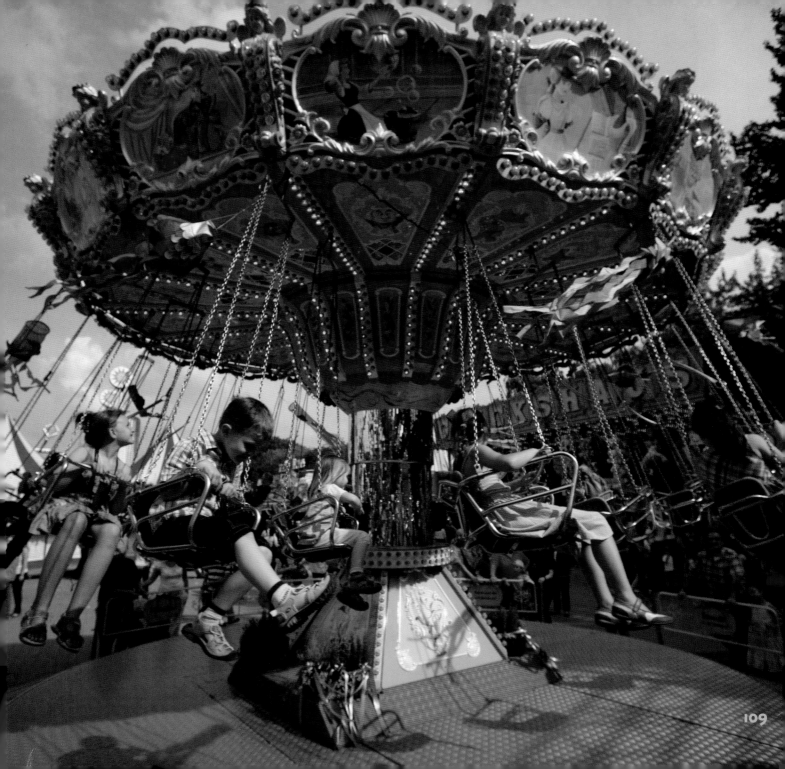

# A Sea of Moving Lights

## From Lofty Heights

Pictures taken from above can be interesting, and there's no place better than the Ferris wheel to get above everything at a carnival. There you will have many chances to take pictures because your perspective will keep changing as you climb higher and higher. Just make sure that you're not afraid of heights! Also remember to wrap the camera's wrist strap tightly around your wrist so you always have a good grip. When you get to the highest point, you'll not only have a great view of the whole carnival, you also might be able to see the surrounding town.

Some Ferris wheels have carts that allow you to turn and look in all directions so you can take pictures of everything. When you're safely back on the ground, you'll know exactly where to find the carousel, the bumper cars, and the haunted house.

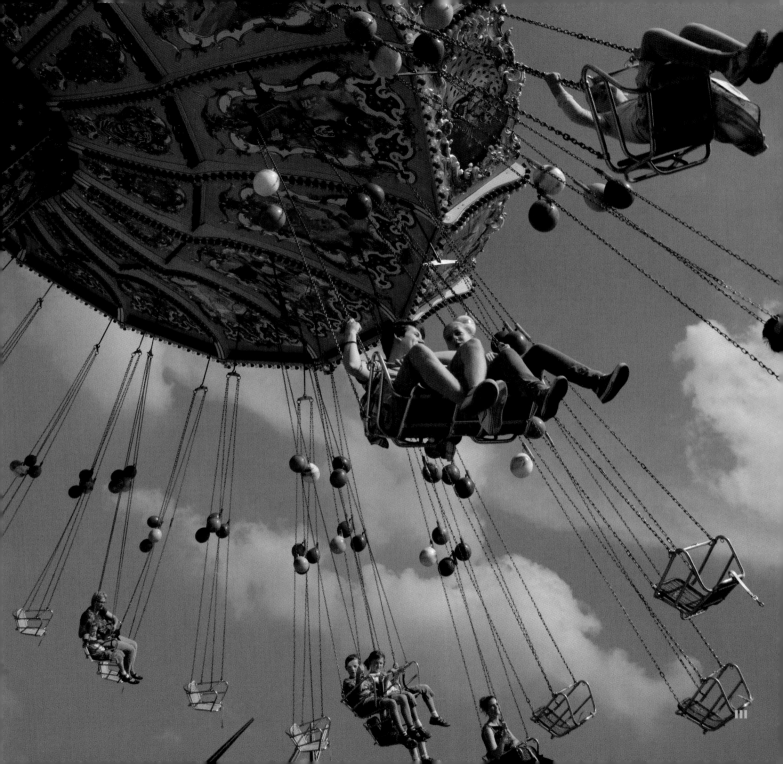

# A Sea of Moving Lights

## The Carnival at Night

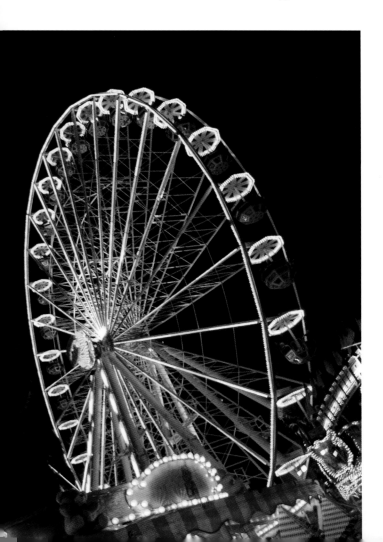

As soon as the sun goes down, crowds of people start to swell, and the workers at the carnival get busier and busier. When it's dark, the bright, flashing lights make the amusement park glow like a sea of many colors under the night sky. The colors change constantly because of the rhythmic, swirling rides that contrast with the eager onlookers who wander slowly through the park. Autumn is a good time to visit amusement parks because the sun goes down earlier in the day, and carnivals are most exciting and beautiful at night.

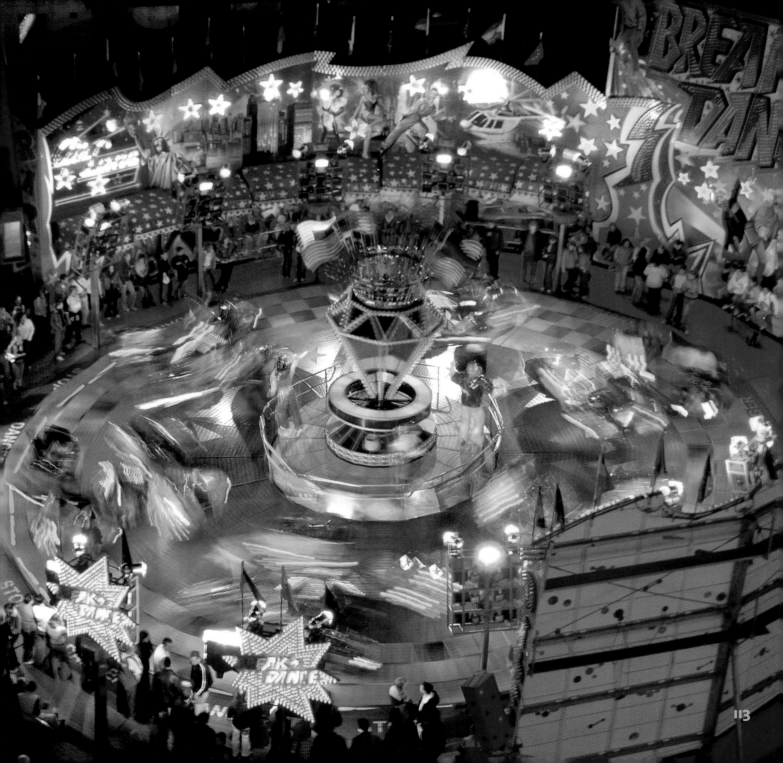

If you'd like to take a picture of a carousel at dusk, use the night flash setting 🖼️ to achieve special effects. The night flash is not as harsh as the normal flash, and the exposure time is longer. This will cause any moving lights in your picture to appear stretched and slightly blurred. Use this method to capture a roller coaster as it zooms by or whenever you want to capture movement in a photograph. In addition, if you move your camera slightly during the exposure time, the colors and images will be even more blurred. Give it a try!

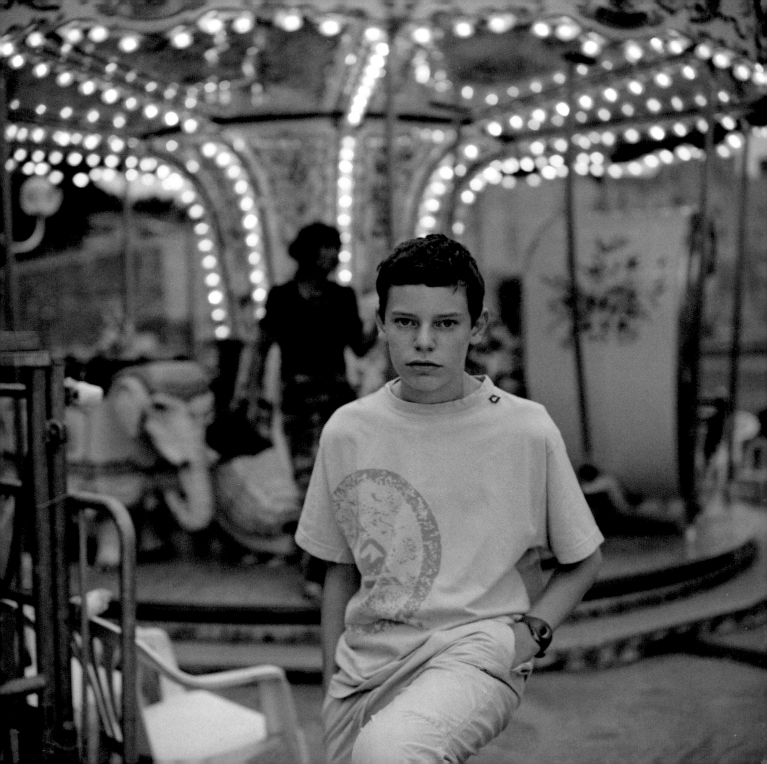

# Happy Birthday!

Birthdays only come once a year, which is definitely not often enough. That's probably why we take so many pictures when we celebrate with all the special people who come together: uncles, aunts, friends, and neighbors. People are in good spirits at birthday parties, there are lots of presents—maybe even a new camera—and there are many chances for fun pictures. Of course, no picture is more important than that of the birthday girl or boy.

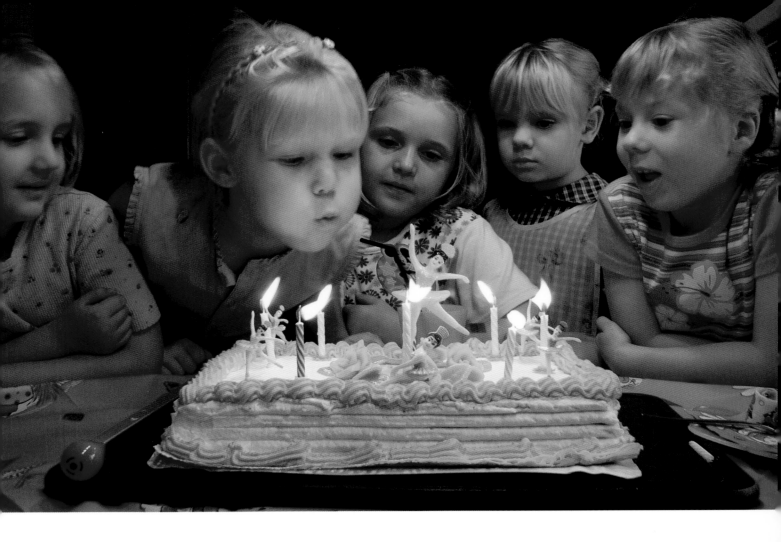

If it's your own birthday, look at the section titled "Self-Portraits" (page 122) for tips on taking pictures of yourself. You can also photograph your guests as they greet you at the door with presents. The highlight of the party is blowing out candles on the birthday cake, but don't forget to capture the table piled high with gifts and the fun and games in the backyard.

When you're invited to a birthday party, you can give your pictures from that day as a gift. Make an IOU that says: "This coupon is good for a photo album with the pictures that I take today at your birthday party." Pictures are always a great gift idea. If you need a gift for your mom or dad, take a self-portrait, have a copy printed, and find a frame that fits. You're all ready!

# Pictures of Me

You've been the subject of many photographs in your lifetime. The earliest pictures were probably ultrasound images that a doctor made while your mother was pregnant. And your parents probably have many pictures of you as a baby and pictures of you at other important moments of your childhood. Most parents love to use cameras to document the lives of their children.

There are probably other pictures of you on special occasions, like opening presents by the Christmas tree, sitting with friends in a circle around a birthday cake, or playing in the sand at the beach with your friends.

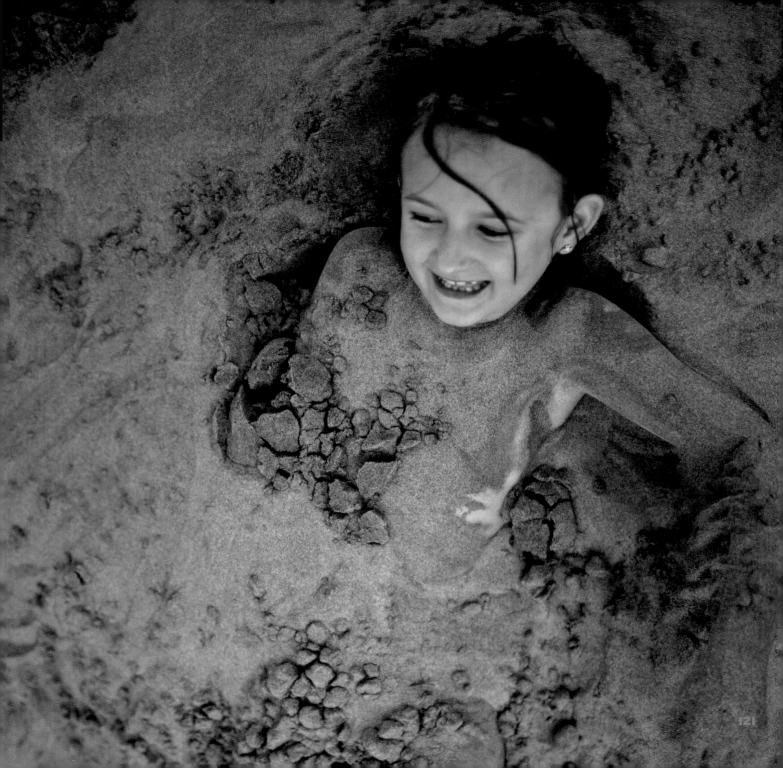

# Pictures of Me

## Self-Portraits

Have you ever taken a picture of yourself? The easiest way is to hold the camera in your hands and point the lens back at yourself. It's important to make sure the zoom is set to a wide angle ▦ because the distance between you and the camera is short, and you want to be able to see as much as possible. Stretch your arm out and press the shutter-release button. You can hold the camera high or low, depending on what type of picture you'd like to take. Have some fun by changing your facial expressions to create a series of different emotions in your pictures, like happiness, worry, surprise, and so on.

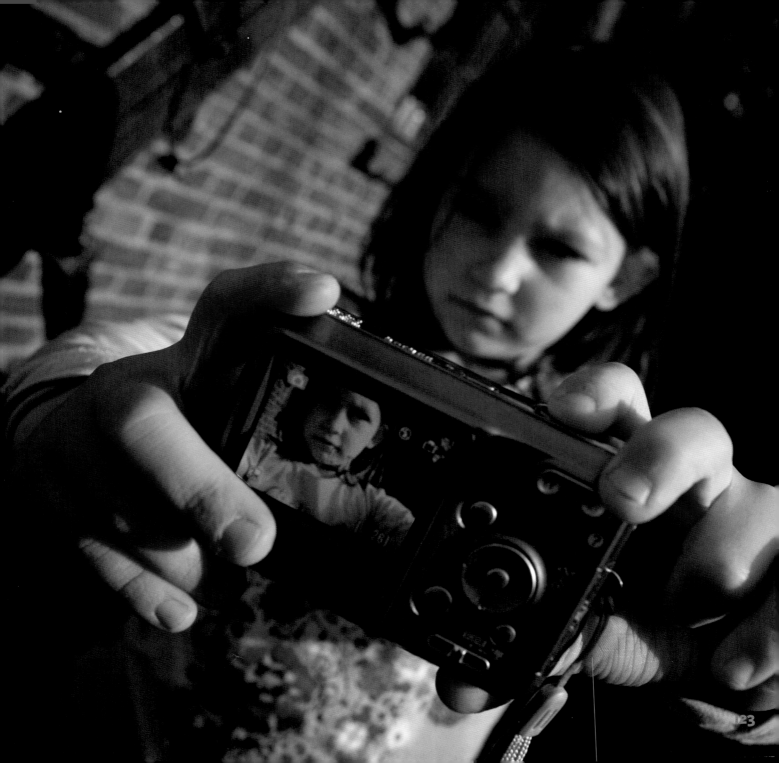

# Pictures of Me

## Self-Timer

The self-timer ⟳ on your camera is another way to take self-portraits. This setting causes the camera to pause for a few seconds between when you press the shutter-release button and when the picture is actually snapped. To use this feature, first turn the self-timer on. You can usually set cameras to pause for five or ten seconds before they capture a photograph. When you're ready, place the camera on a flat and steady surface like a bookshelf, table, or wall so the camera won't fall. Examine the live display to see the scope of your picture and press the shutter-release button when you're ready. Now you've got a few seconds to get into place before the camera takes a picture.

Sometimes you'll get funny pictures if you don't quite manage to get into place in time. The picture may have only a forearm in it, or someone's head may be clipped off. The picture will turn out perfectly if you figure out exactly where you should be.

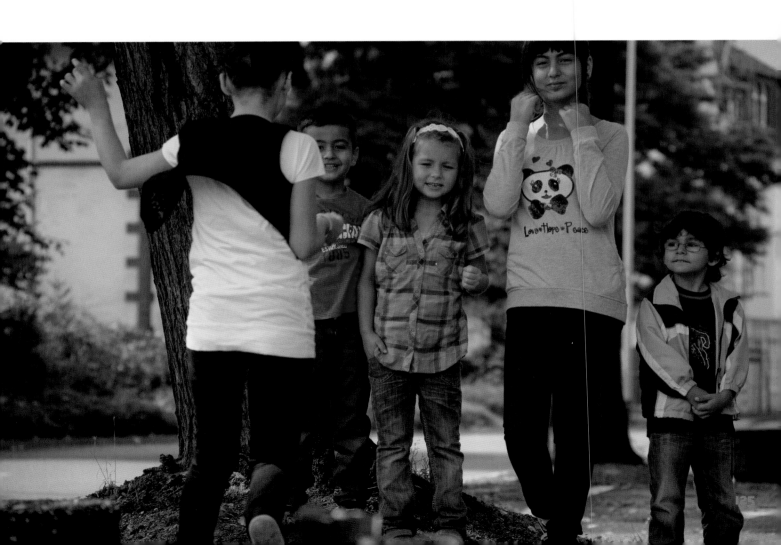

# Pictures of Me

## Reflections

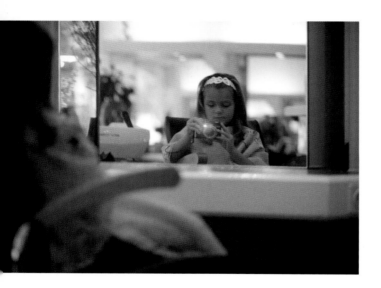

Mirrors are also helpful if you want to take a picture of yourself. If there is more than one mirror—in a hair salon or bathroom, for example—you can have lots of fun photographing reflections of reflections. At the carnival you can use distorting mirrors that make you appear larger or smaller, wider or thinner to take pictures of yourself. Everything that reflects light can be an opportunity for a self-portrait: windowpanes, puddles, shiny metal surfaces, or even a doorknob. Don't forget to turn off the flash because it will also be reflected, and it will drown out anything else in the picture.

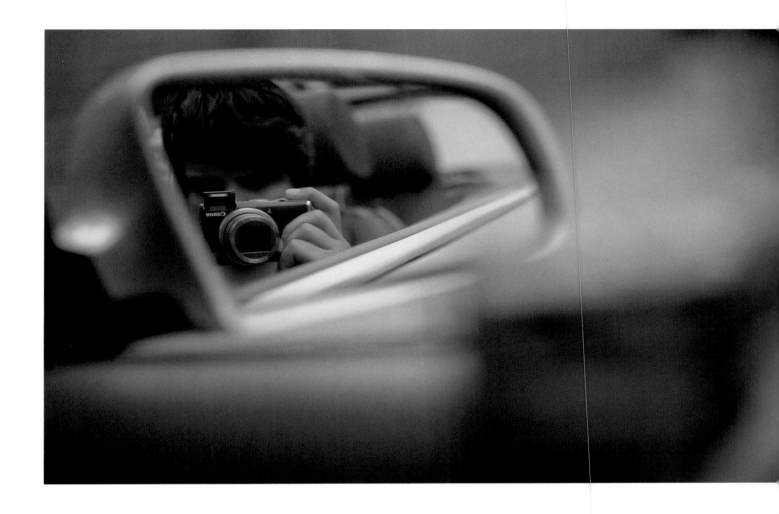

Shadows can be portraits, too. The sun sits very low in the sky during dusk at the end of summer, which causes everything in the open to cast a long shadow. Stand with your back to the sun and check out your body's shadow. Move around to create interesting shapes and take cool pictures of what you see.

It can be interesting to make a diary of self-portraits. Take a picture of yourself every day for a long time. Afterward, you'll be able to see how you've changed from picture to picture.

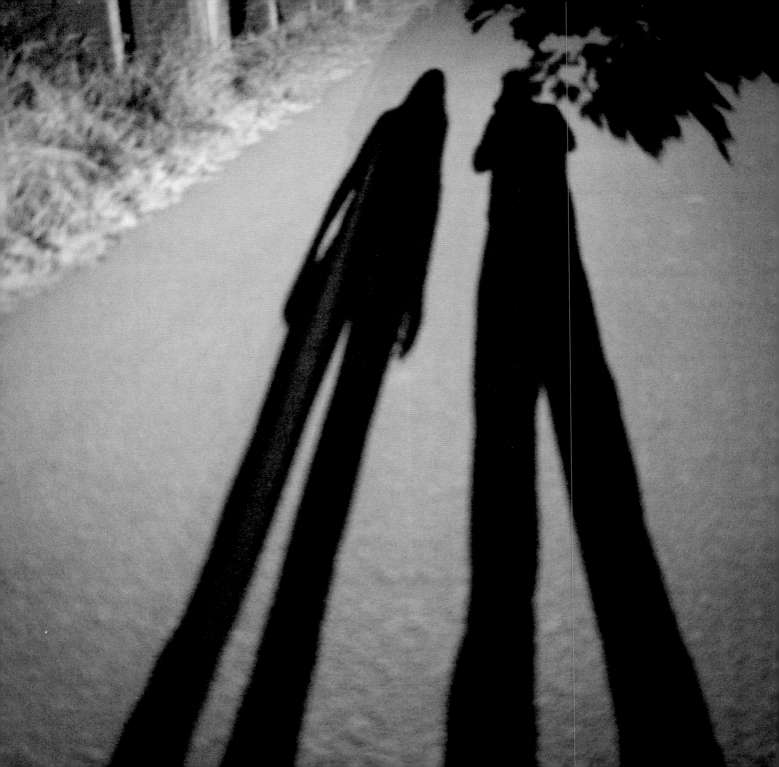

# My Hometown

You probably know your hometown as well as you know the back of your own hand. Even if you've just moved to a new place, you may have found interesting sights on a discovery tour or by running everyday errands with your family. If you wander through your town, you are sure to find lots of exciting things. Towns change with every season. In spring, shop windows have displays of colorful Easter eggs, bunnies, and candy-filled baskets. In summer, street cafés are open and full of people. Mannequins in department stores are dressed in tank tops, shorts, and sandals, and ice cream cones are everywhere. In autumn, the shops have jack-o'-lanterns, spiders, and witches in the windows for Halloween. And in winter, towns put up Christmas trees with strands of lights in public squares.

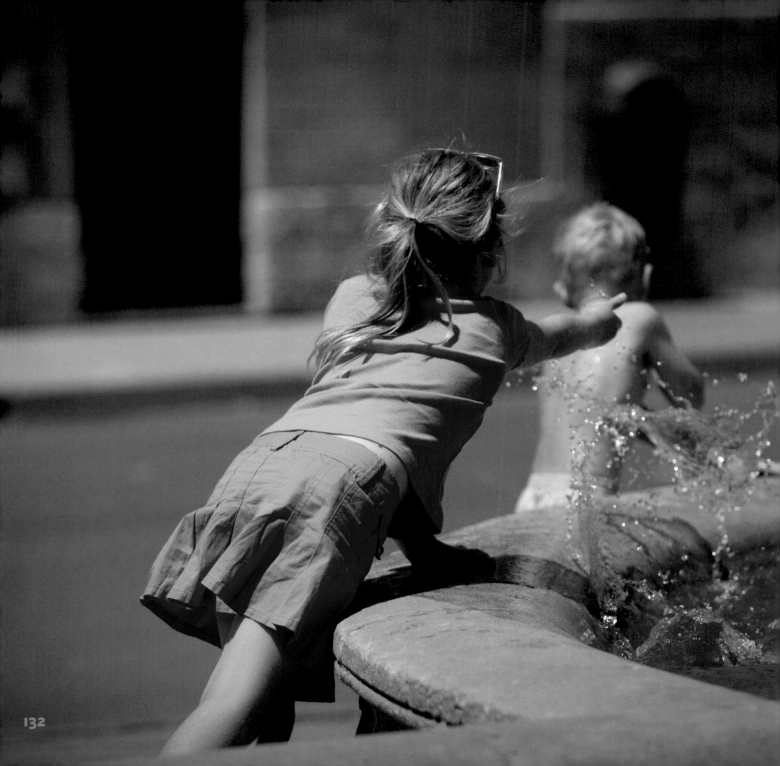

It's always exciting to see how people live in your own city. Children press their noses against shop windows to check out the newest toys. Shoppers rest on park benches with their bags full of new clothes. A boy lets go of a balloon that floats up to the sky just as you pass by. A street merchant sells his wares to people who pass him. Since the street is a public place, you're allowed to capture all of these events with your camera.

You may want to make a photo story of your adventure by collecting pictures that relate to a theme you find interesting, like a city festival or a farmers' market. Record everything you see with your camera. You're always allowed to take pictures in the open, but if you're inside a store, you need permission from the shop owner.

Find an interesting spot in your town—one that you walk by regularly—where people like to gather, like a fountain. Take a picture from the exact same spot every day for a whole week and then compare your pictures afterward to see how the spot changes from day to day.

# What to Do with All of Your Cool Pictures

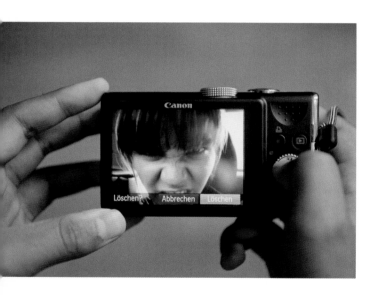

Before deciding which pictures to keep or delete, always look at them on a large computer screen. After you've chosen the ones you really like, you can erase the others with the camera's *delete* button 🗑. It's wise to take more than one picture of your subject so you can try different perspectives and so you can make sure to get at least one good photo. Not every picture will be worth saving, though; less is more, as they say. If you tried to save all of your pictures, your computer's memory would run out, and you'd lose track of the pictures you like.

# What Should I Keep?

Now it's time to decide which pictures you'd like to save. It's not just a matter of deciding which pictures turned out the best; you also need to consider what each picture means to you. Imagine you were only able to take one picture of your friend blowing out the candles on a birthday cake, and unfortunately it turned out blurry. You wouldn't want to delete this picture because it captures a moment that you'd like to remember. So hold on to it because it's important to you, whether it's blurry or not. Out-of-focus pictures can be exciting, especially if you're photographing something that moves.

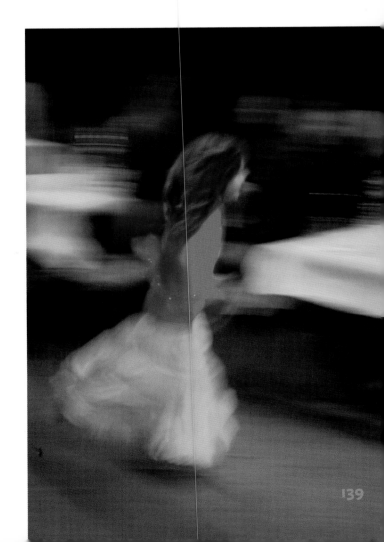

## What Should I Delete?

If you've taken a series of ten portraits of your friend, and she blinked in five of them, the choice is easy: erase the ones with her eyes closed. Sometimes you will have photos that are almost exact duplicates because you took one right after the other. You can delete these unnecessary copies without worrying.

Don't delete pictures until after you've looked at them on your computer's large screen. Sometimes pictures that first seem to be mistakes actually look really cool. Use your instincts to decide which pictures to save.

# What to Do with All of Your Cool Pictures

## Saving Pictures: Where and How

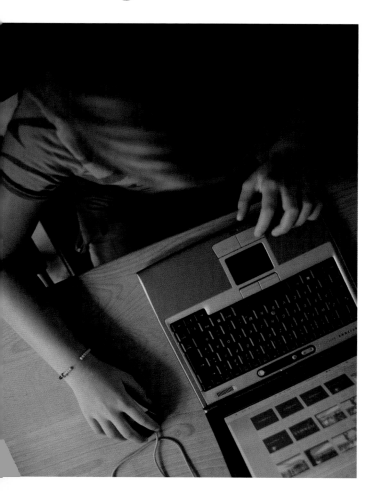

It's important that you save your pictures in a way that allows you to easily find them again. You shouldn't just dump them somewhere on your hard drive without thinking about how to organize them. Open the *My Pictures* folder on your computer and create new subfolders for each year. Within each year folder, create other folders based on different themes or events. You might have a folder named *Yellowstone Vacation*, for example, or *Jenny's Birthday*, or *Self-Portraits*. Some people choose to organize their pictures by month instead of by theme. Choose the system that seems easiest to you. No matter how you end up saving your pictures, talk to your parents about backing up your files, because if your computer crashes, you'll be really sad if you lose all of your pictures.

Your camera records the time and date of every picture that you take, and many computer programs allow you to search your pictures for this information. If you have trouble finding a picture from your birthday party, for example, search your files for pictures that were taken on that specific day. Make sure that the clock in your camera is set to the correct date and time. You can read about how to set the clock in the instruction manual for your camera.

# What to Do with All of Your Cool Pictures

## Sharing Your Pictures with the World

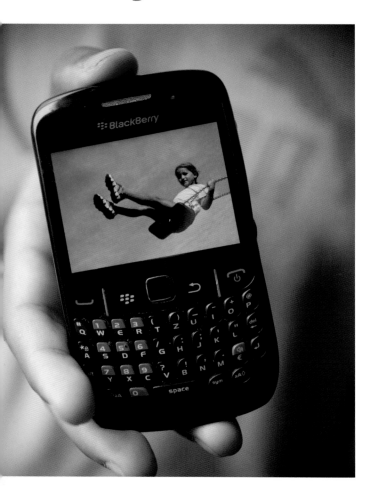

Sharing your pictures is almost as fun as taking them. It's not possible to see all of your friends every day, but with e-mail, you can easily send your pictures to them. Your friends in different states and your friend across the street can receive and view your pictures on their own computers in just a matter of seconds. And if you have a cell phone with a camera, it's even easier; just send a picture from your cell phone directly to your friend's cell phone. This service can be expensive, though, so check with your parents before using it.

If you have friends who live far away, you could send them a picture once a week to show them what you're up to.

# What to Do with All of Your Cool Pictures

## Your Pictures on the Internet

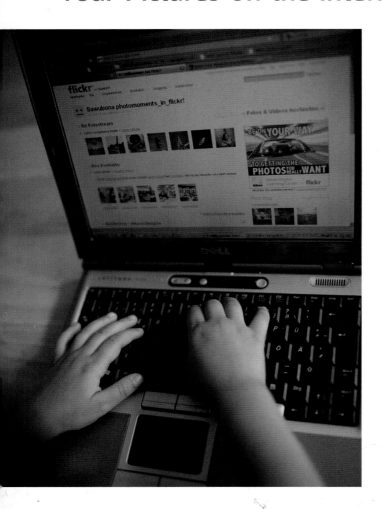

You probably already know your way around the Internet pretty well. There are countless websites—like Picasa and Flickr—that allow you to make a public gallery of your pictures. It can be a lot of fun to share your best pictures with the world, but there are a few things to consider before making your pictures public.

After a picture is published on the Internet, it can be difficult to delete it. In addition, other people will be able to download your pictures onto their computers without you knowing it. Talk it over with your parents to decide if you really want to make your pictures public. If there are other people in your pictures, be sure to ask them what they think about it, too.

# What to Do with All of Your Cool Pictures

## Printing Your Favorite Pictures

If you view your pictures only on your computer screen, you're likely to get bored. Sometimes it's nice to hold your favorite pictures in your hand or frame them and hang them on the wall. You may even want to carry a picture of a loved one around with you. Printed pictures also make good gifts. If your parents have a good color printer and photo paper, you can make your own prints at home, but usually it's less expensive to have a store print pictures for you. Drug stores, supermarkets, and photo stores have special machines that will print pictures on demand. You can also order pictures on various websites. Have your parents help you, and in just a few days you'll get your pictures in the mail.

Have five of your favorite pictures printed so they are the same size. Then find frames that are also the right size, and make sure it allows you to change the pictures easily. Now you can hang up and change your favorite pictures whenever you like.

# What to Do with All of Your Cool Pictures

## Today's Photo Book Is Yesterday's Photo Album

People used to put their pictures in photo albums. Thanks to new technology, it's possible to make your own printed books that look like this book. If you want to have a book printed about your fun adventures during summer vacation, there's no reason you can't make that book yourself. Everything can be made into a book. With a little practice, you can use a free computer program to create the book yourself and then order prints of the book from a website. As always, it's a good idea to find someone who has already made a photo book to help you out.

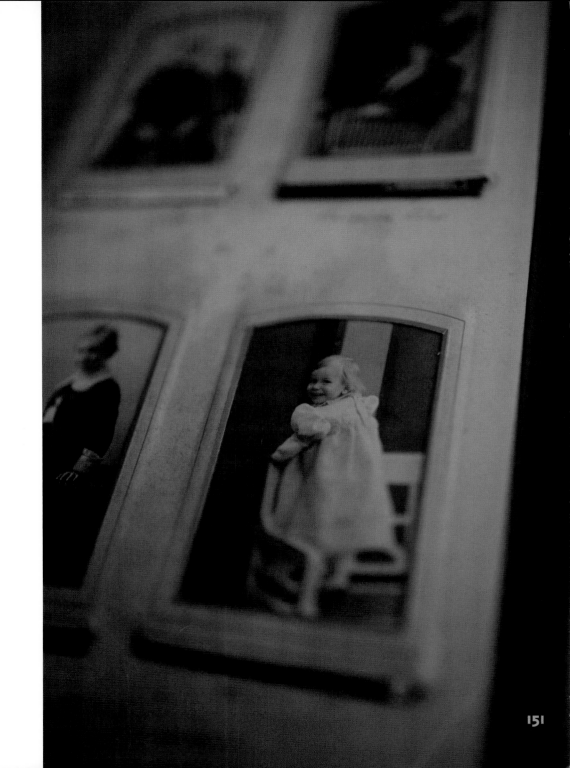

# The Ending Is Just the Beginning

We've provided several exciting ideas and suggestions for you, but this is just the beginning. You'll find countless other opportunities to take great pictures, like Halloween, cooking a big meal in the kitchen, the town parade, or football games at your local high school. Wherever you go, you'll find subjects to photograph, so grab your camera and explore your world. In no time at all you'll find subjects and themes that you love.

Photography is one of the most delightful ways to spend your time, and with new technology you can take amazing pictures with basic technical awareness. It's not possible to go into all the details of your particular camera in this book. As soon as you're ready to dig deeper into your camera's functions and your computer's technology, look at the instruction manual that came with your camera. You'll find valuable information and answers to your questions. You can also find many websites with useful information and tips.

Staying excited about taking pictures is what's most important. Hopefully, by reading about photography and looking at amazing pictures like the ones in this book, you will want to discover your own world with your camera.

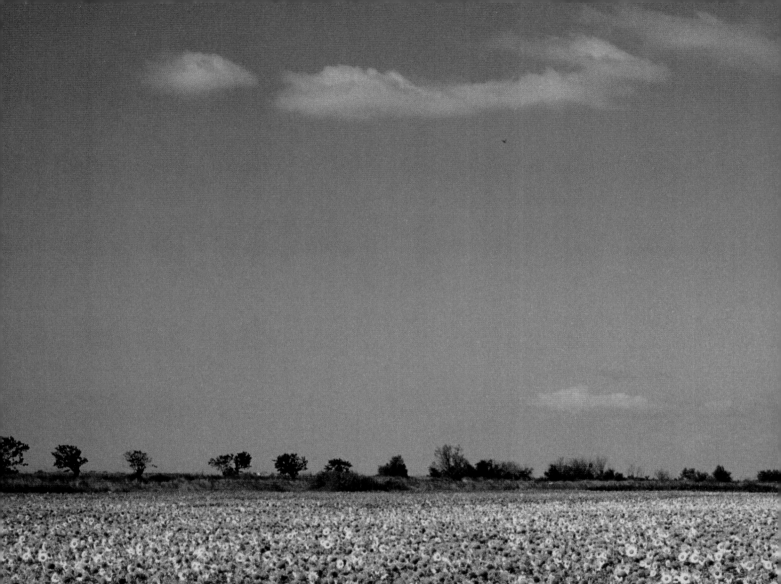

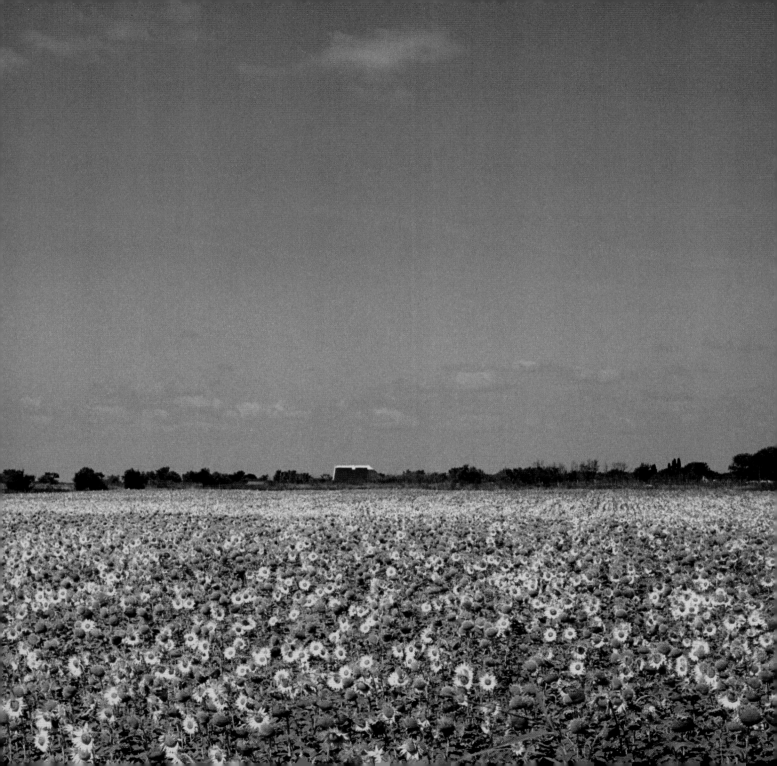

# Glossary

**autofocus**

The autofocus sets the range of the lens to the correct distance so your pictures won't be blurry.

**autofocus indicator**

When taking a picture, the autofocus indicator identifies the object that is used to set the lens's range. On most cameras, the autofocus indicator is a small green box that appears on the display. If the picture is blurry, the focus indicator will blink.

**camera**

A camera is a device we use to take pictures.

**card reader**

A card reader is a device that attaches to a computer and can read your camera's memory card. It's used to transfer pictures onto your computer's hard drive.

**chip**

See *sensor*.

**display**

The display is the screen on the back of the camera. In shooting mode, the display shows a live image of what the lens is pointed at. In review mode, the display shows images that have already been captured.

**exposure time**

The exposure time is the length of time it takes for your camera to take a picture.

**film**

Before digital cameras and sensors were invented, people used film to absorb light and take pictures.

### flash

The flash is a small but powerful light that turns on for a brief moment while the camera takes a picture. It allows you to take photos when there is not enough natural light.

### hard drive

All files, including pictures, are saved on a computer's hard drive. A memory card serves the same purpose in a camera.

### lens

The lens is the eye of the camera. It's made up of many glass lenses similar to the lenses in eyeglasses or microscopes.

### macro

The macro setting allows you to get really close to your subject and also allows you to make small objects look large.

### memory card

Pictures that you take with your camera are saved to the memory card. There are different types of memory cards, but the most common ones are small SD cards. More than 1,000 pictures can fit on a single memory card, depending on how large the pictures are.

### motion blur

During a long exposure time, anything in front of the camera that moves will cause blurring and will be out of focus.

### night flash

The night flash is a special flash mode. In contrast to the normal flash, the night flash is not as bright and has a longer exposure time. If you need to use a flash, rely on this setting to help you create beautiful pictures.

# Glossary

**photo shoot**

A photo shoot is a scheduled occasion for a photographer to take several pictures of someone. The term comes from advertising photography.

**photography studio**

A photography studio is a workplace for photographers. Photographers take, edit, and sell pictures there.

**picture angle**

The picture angle determines the left and right limits of a picture's frame.

**picture browser**

A picture browser is a computer program designed to display pictures on a computer screen.

**portrait**

A portrait is a picture of a person that usually shows their face. If you take a picture of yourself, it's called a "self-portrait."

**reflection**

To reflect is to throw back light. Everything reflects light to some degree. Light-colored objects reflect more light, and dark-colored objects reflect less light.

**review mode**

Review mode allows you to see what you've already photographed. You can review all of your pictures on the camera's display.

**self-timer**

The self-timer makes it possible to delay the moment when your camera takes a picture. If you turn the self-timer on, a few seconds will pass between when you press the shutter-release button and when the camera snaps a picture.

## sensor

The sensor, or chip, absorbs images, which are then saved on the memory card.

## shooting mode

In shooting mode, you'll see a live image on the camera's display that you can capture by pressing the shutter-release button.

## subject

The subject of a photograph is what you're trying to show in your picture. Anything can be a subject: people, animals, or things.

## telephotograph

A telephotograph is a picture with a tight angle. It allows you to make your subject fill up more of a picture's frame. You might want someone's face to take up the whole picture, for example.

## wide angle

A wide angle allows you to take a picture of almost everything you can see. You would use a wide angle to take a photo of all your classmates, for example.

## zoom

The zoom is a lens that allows you to determine the boundaries of your picture's frame. Sometimes you'll want to draw attention to one specific detail, and sometimes you'll want to capture a larger area. Sometimes you'll have a subject that is big and close, and sometimes you'll have a subject that is small and distant.

Friends of the
Houston Public Library